T. J. WILCOX

FILMS

Galerie Daniel Buchholz, Cologne
Sadie Coles HQ, London
Metro Pictures, New York

jrp|ringier

TABLE OF CONTENTS

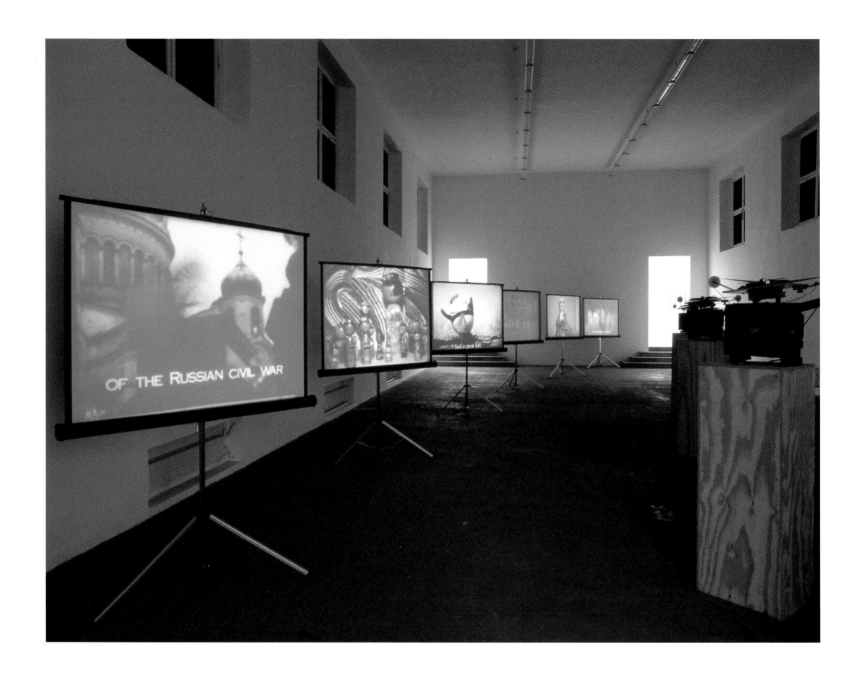

GARLANDS

GARLAND ONE
—*Ann*
—*The Execution of Ortino*
—*fraise des bois*
2003, 16mm film, 8 minutes, 6 seconds

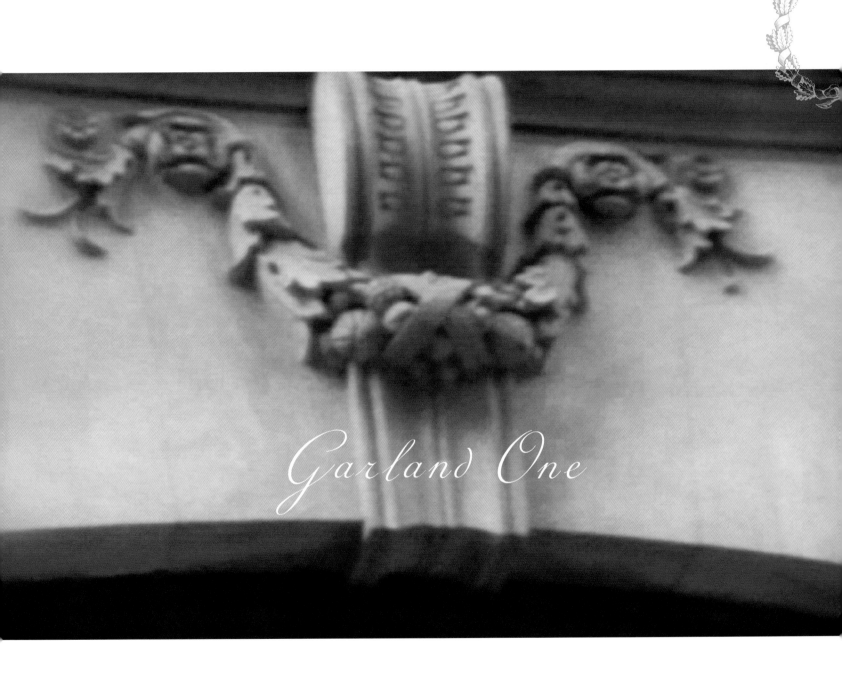

Garland One

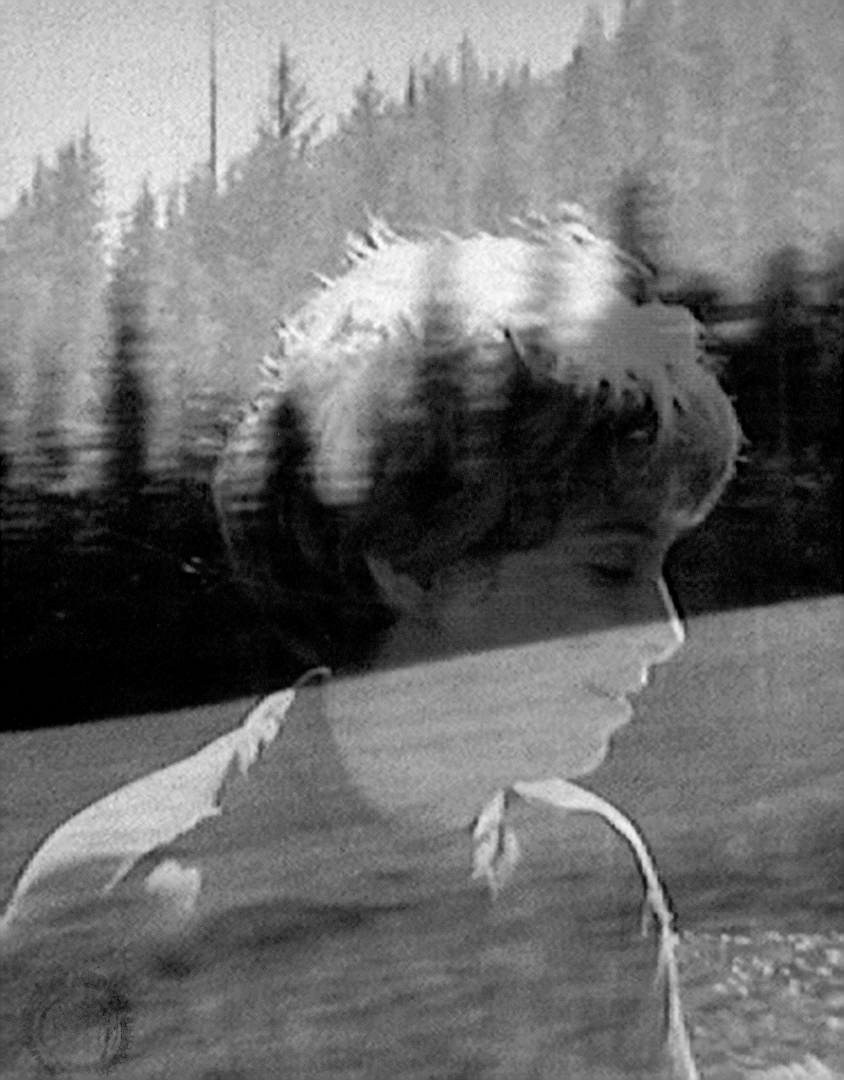

Growing up I had four parents
one of whom was called Ann.
Extraordinarily kind and great fun
she was also
the first innately cool person
I had ever met.
She died on her 42nd birthday
when I was eighteen.
She was typically candid
about her burial wishes.
Uninspired by the prospect
of a single gravesite
she chose several
so she would always be
in her favorite places.
We divided her ashes
in three parts:
Hurricane Ridge
Olympic National Forest
next to her Father;
Long Island, New York;
Peter Pan Garden,
Hyde Park, London

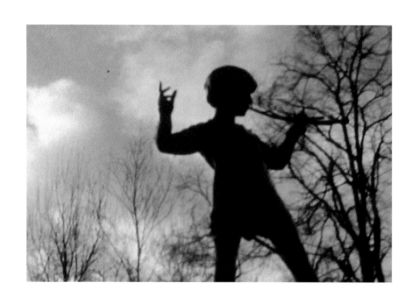

THE EXECUTION OF ORTINO

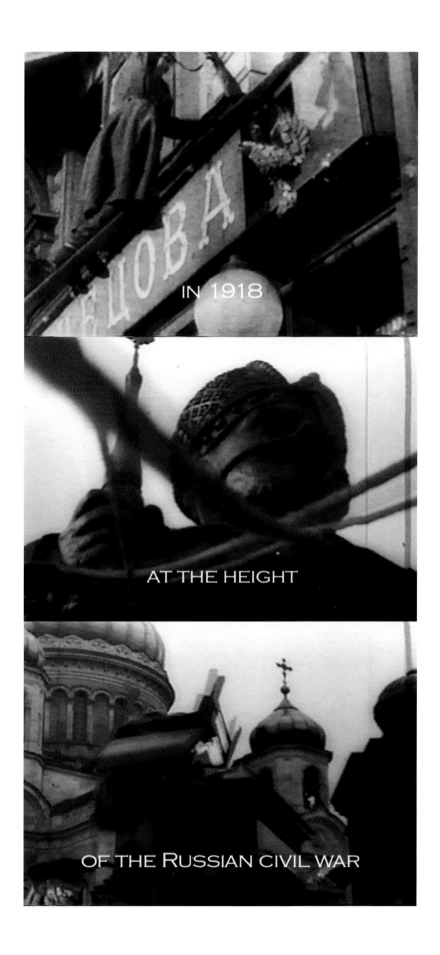

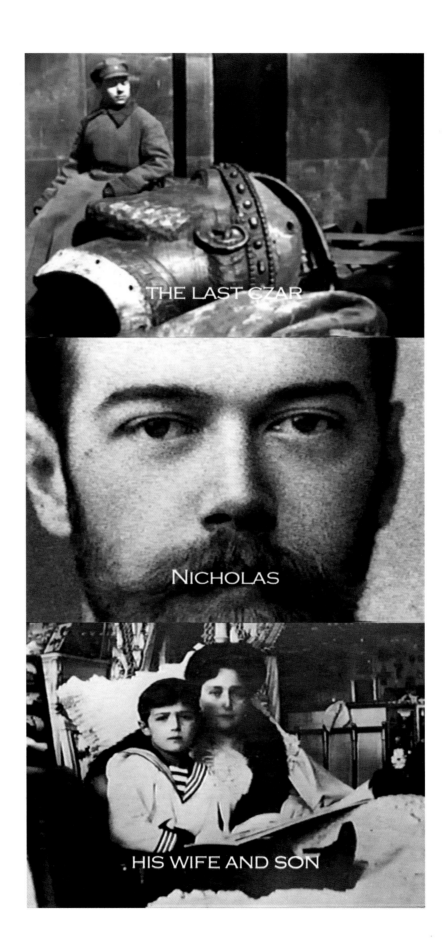

THE LAST CZAR

NICHOLAS

HIS WIFE AND SON

AND THEIR FOUR
BEAUTIFUL DAUGHTERS

WERE SENT TO A HARSH EXILE

IN A REMOTE SIBERIAN VILLAGE.

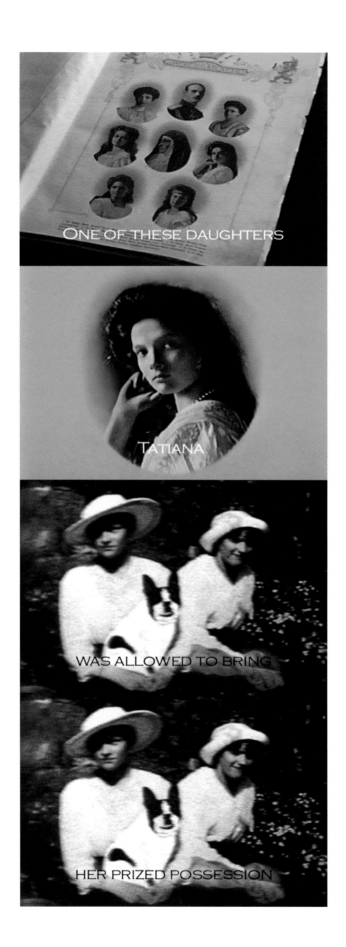

ONE OF THESE DAUGHTERS

TATIANA

WAS ALLOWED TO BRING

HER PRIZED POSSESSION

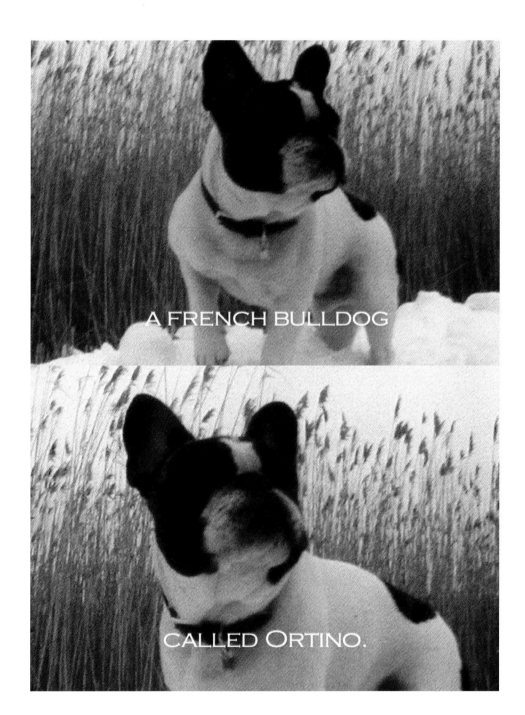

A FRENCH BULLDOG CALLED ORTINO.

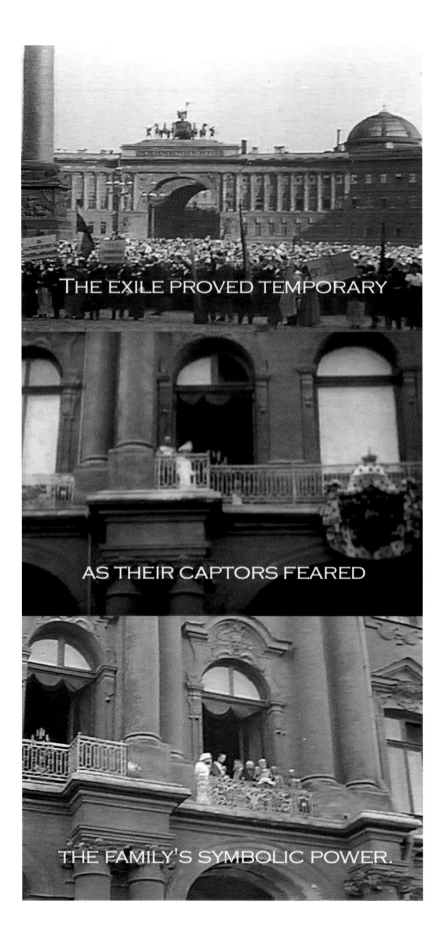

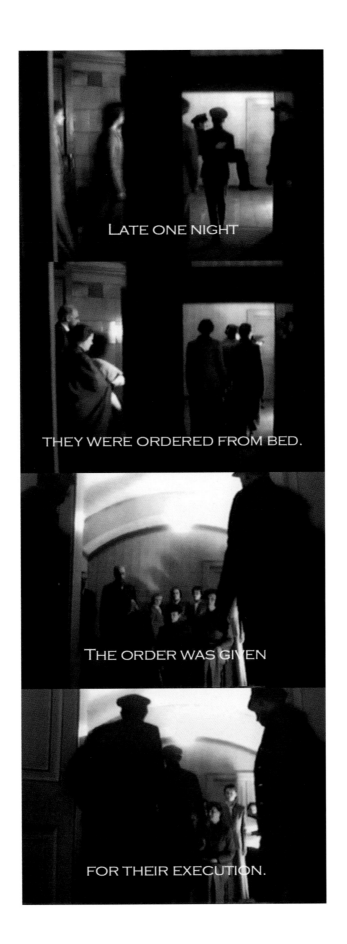

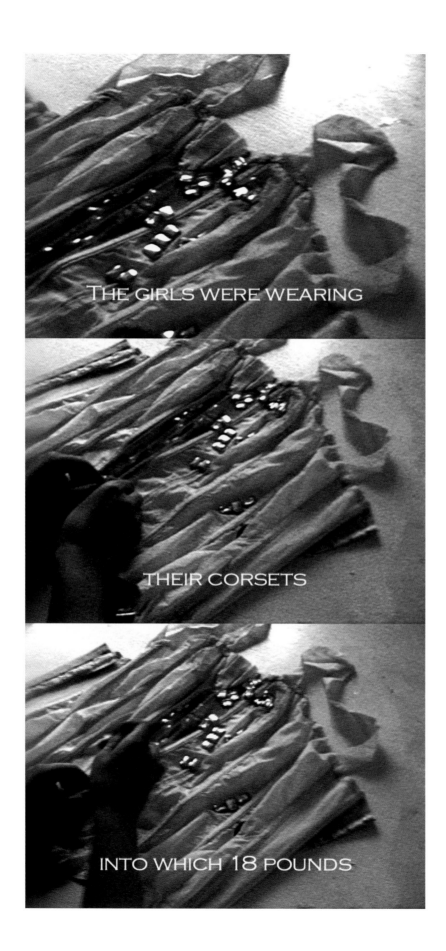

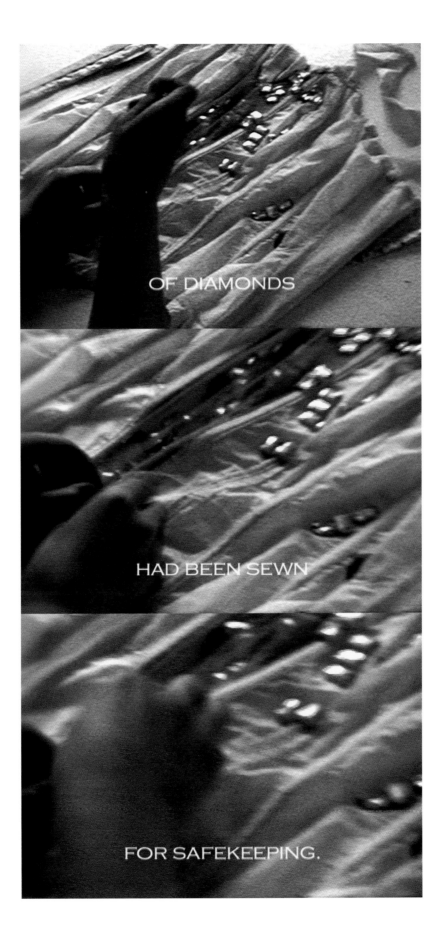

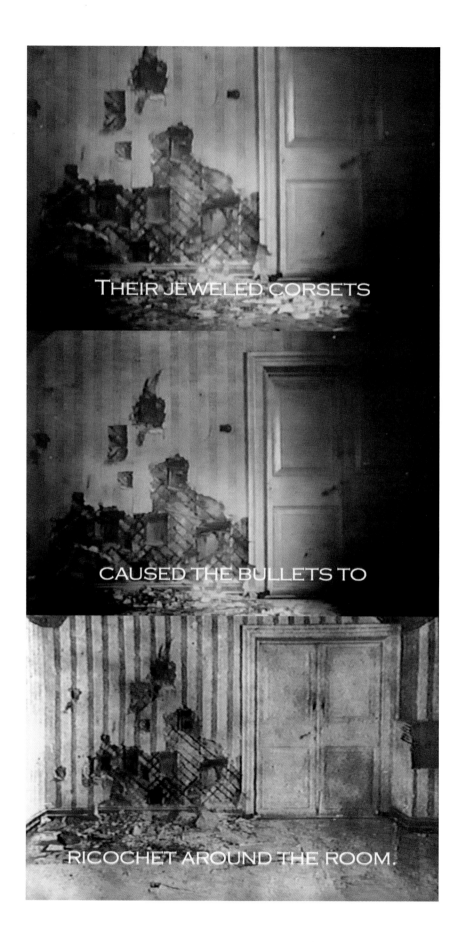

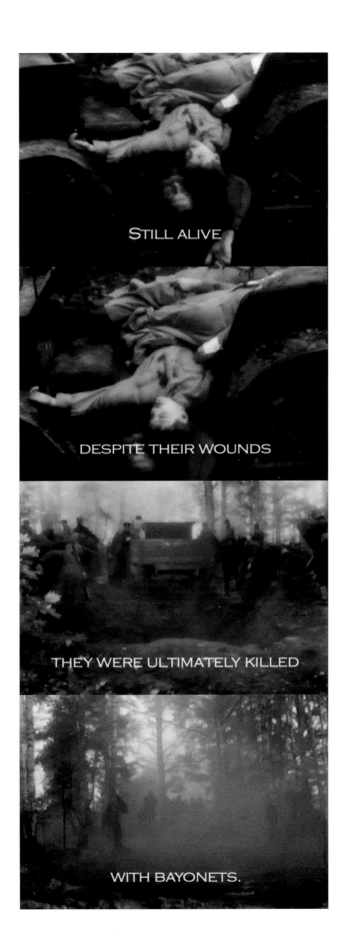

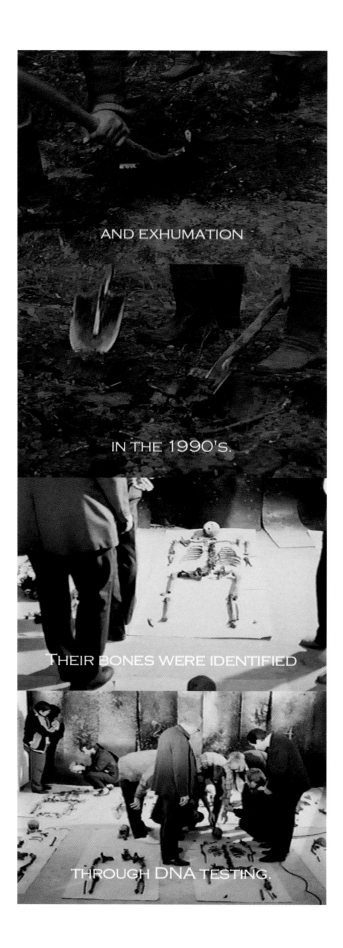

INCLUDED IN THE MASS GRAVE

OF THE ROMANOVS

WAS THE TINY BODY

OF ORTINO.

FRAISE DES BOIS

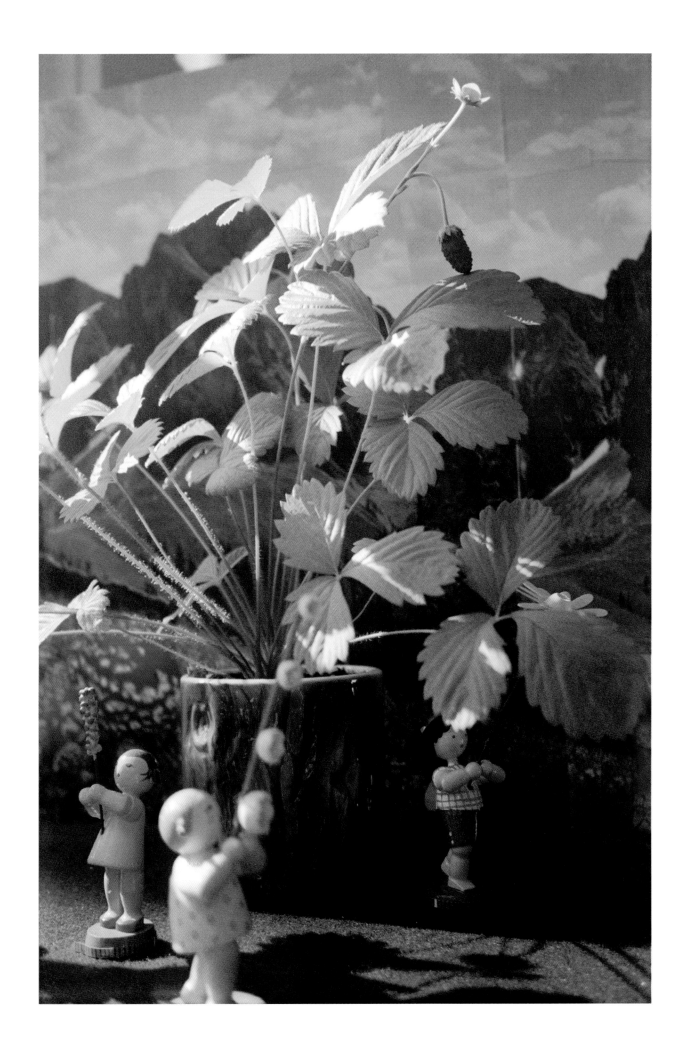

GARLAND TWO
—Mad Dash (Carrie)
—Ara Tripp
—Kokeshi
—Annunciation
2003, 16mm film, 5 minutes, 47 seconds

Garland Two

MAD DASH (CARRIE)

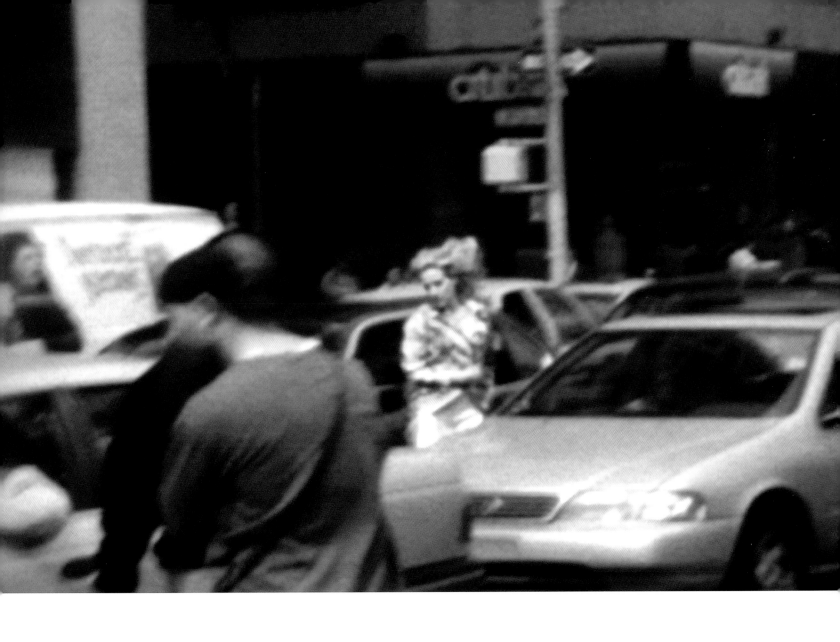

ARA TRIPP

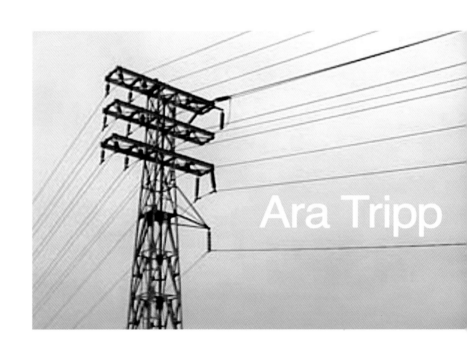

Ara Tripp

Early on the morning
of September 8, 1999
in Seattle, Washington,
Ara Tripp,
post-operative transsexual
and transgender rights activist,
climbed to the top
of a 150 foot tower
which supported power lines
carrying 120,000 volts
of electricity.
Once atop the tower
Ara Tripp removed her top
and played air guitar.
She also took swigs
from a vodka bottle
which she then lit
with a butane lighter,
blowing 15 foot
flames of fire.
5,000 homes and businesses
lost electrical power.
She was protesting "decency" laws
which prohibit women
going topless in public.
"I see guys
with bigger boobs than mine
with hair on them
and it's legal."
After several hours
Ara Tripp returned to ground
of her own accord.

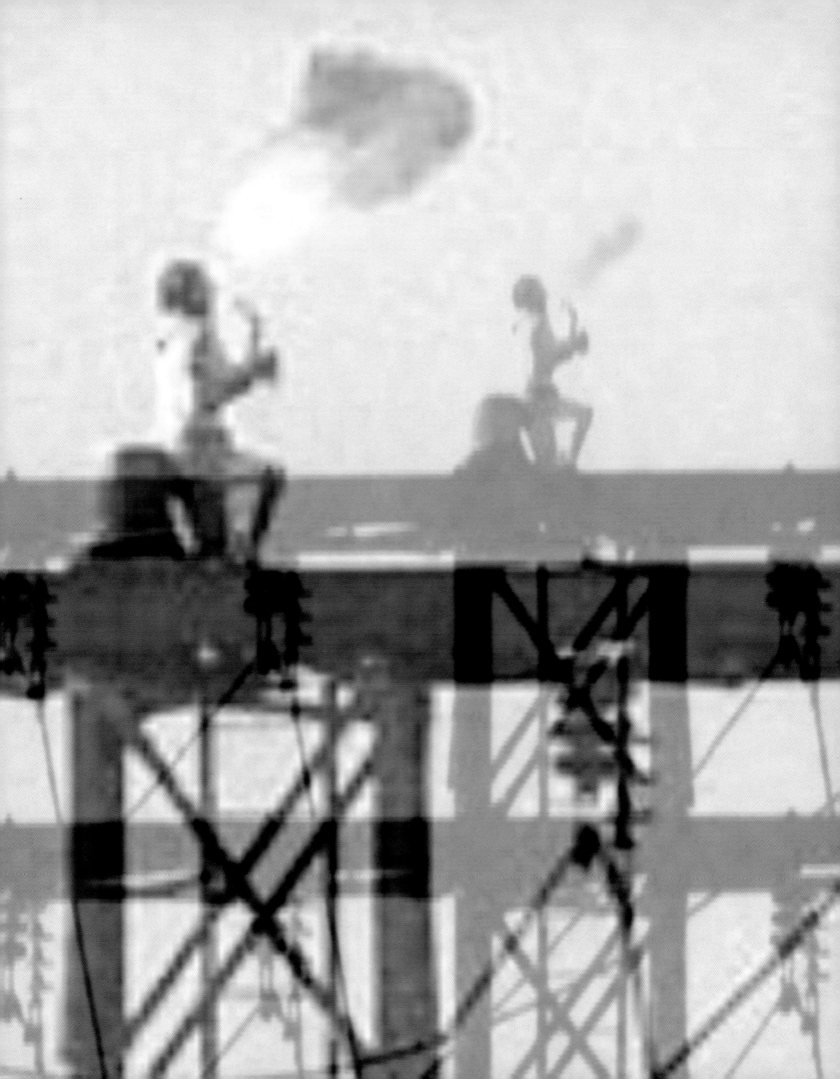

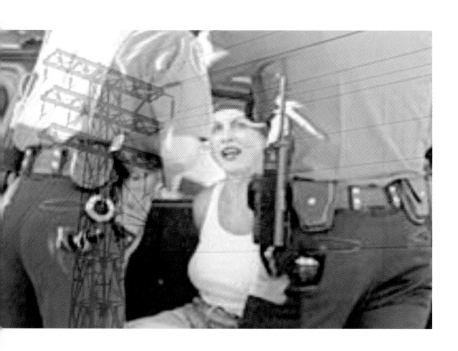

KOKESHI

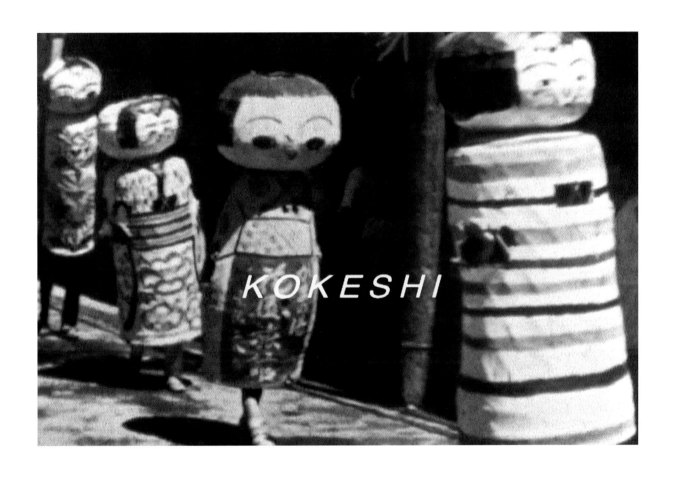

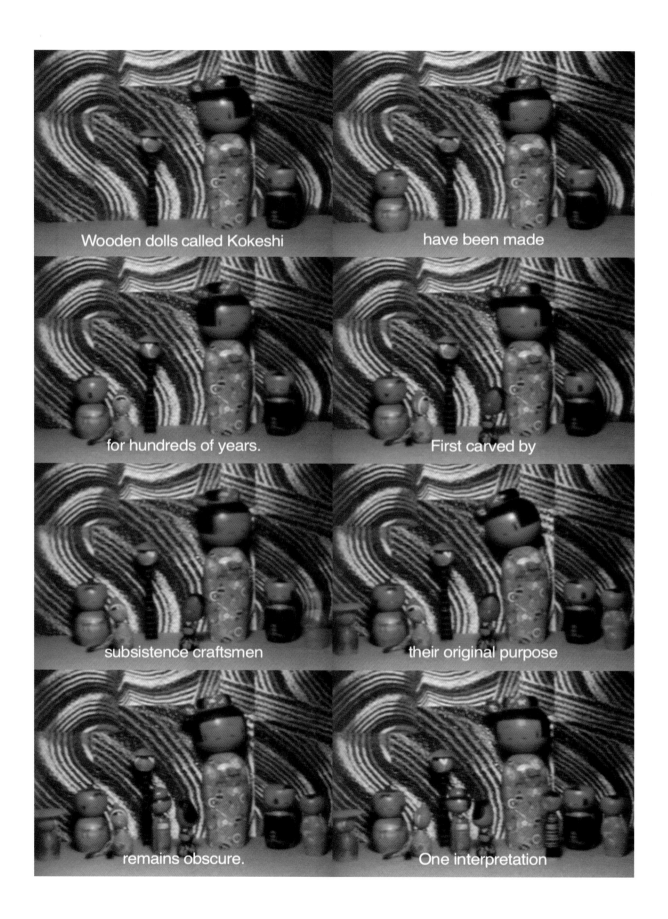

Wooden dolls called Kokeshi

have been made

for hundreds of years.

First carved by

subsistence craftsmen

their original purpose

remains obscure.

One interpretation

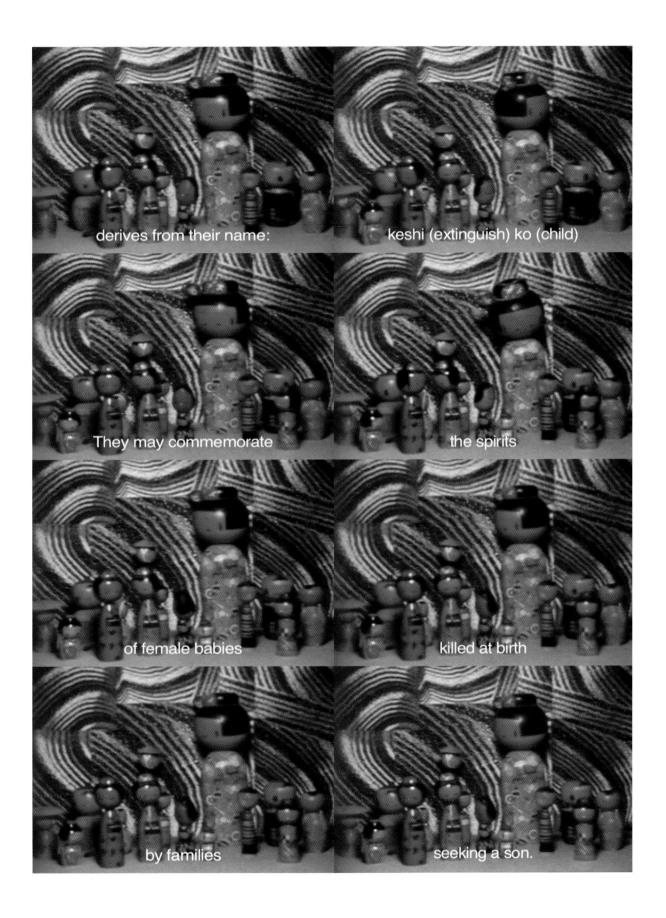

derives from their name: keshi (extinguish) ko (child)

They may commemorate the spirits

of female babies killed at birth

by families seeking a son.

ANNUNCIATION

GARLAND THREE
—*Around the World in Eighty Seconds*
—*How to Explain the Ephemeral and Tenuous*
 Character of Life to Children
—*Monogram*
—*Sunset*
2003, 16mm film, 9 minutes, 5 seconds

Garland Three

Around the World
in Eighty Seconds

San Francisco

New York

Miami

London

Paris

Athens

Marrakech

Dehli

Tokyo

Los Angeles

Las Vegas

Havana

Rio de Janeiro

Berlin

Rome

Cairo

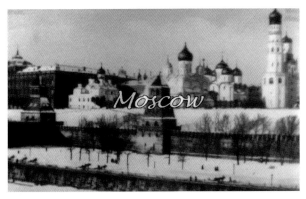

Moscow

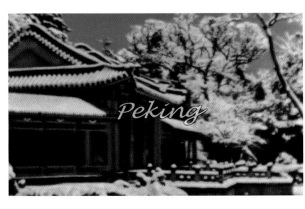

Peking

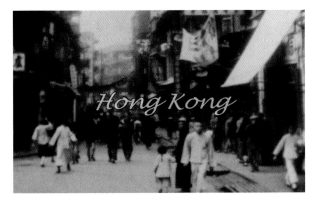

Hong Kong

HOW TO EXPLAIN THE
EPHEMERAL AND TENUOUS
CHARACTER OF LIFE
TO CHILDREN

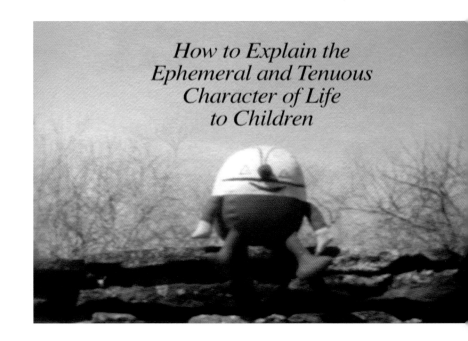

*How to Explain the
Ephemeral and Tenuous
Character of Life
to Children*

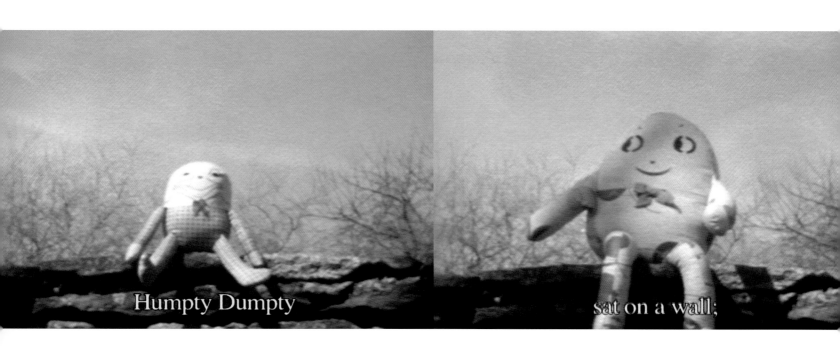

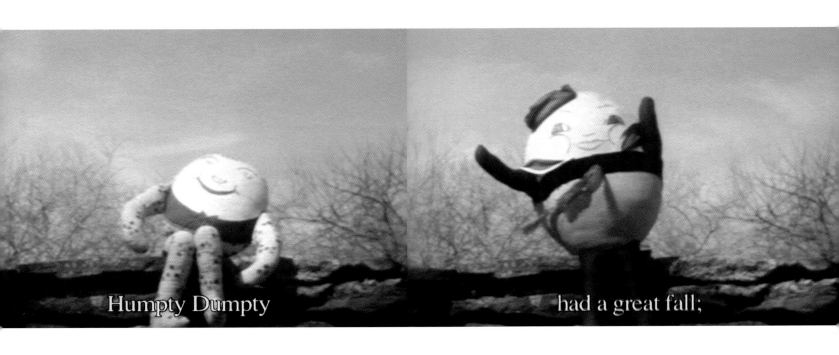

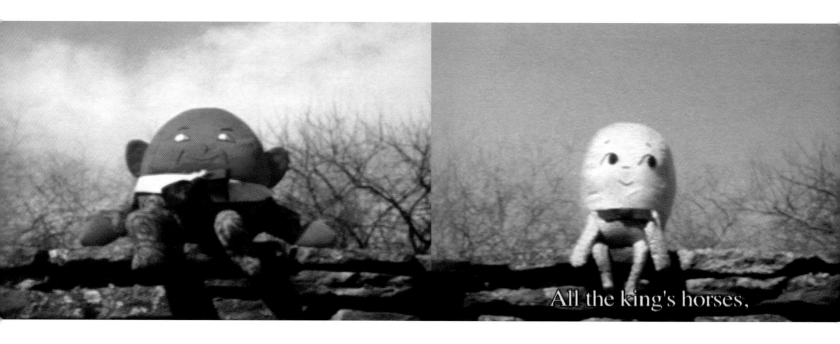

All the king's horses,

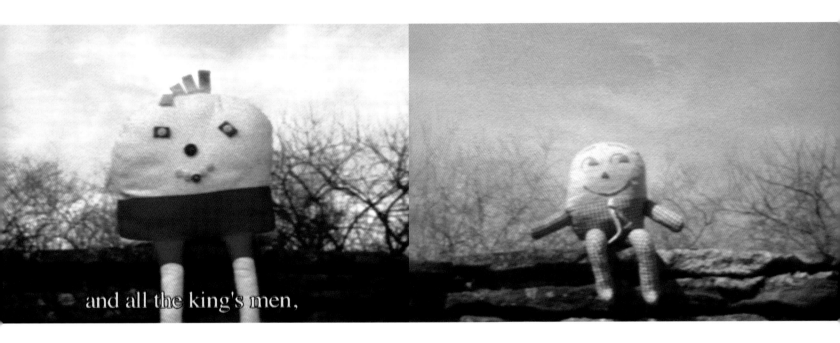

and all the king's men,

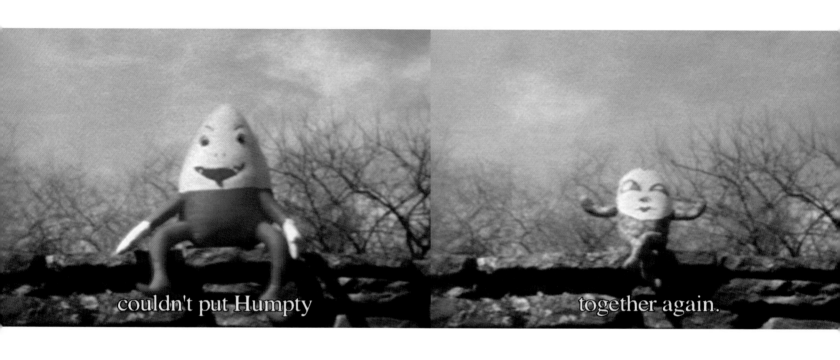

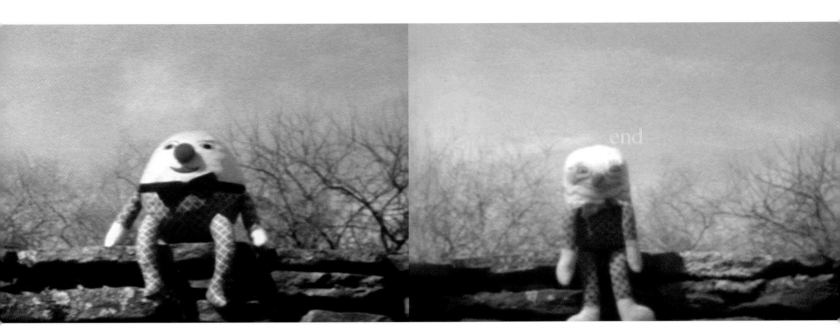

MONOGRAM

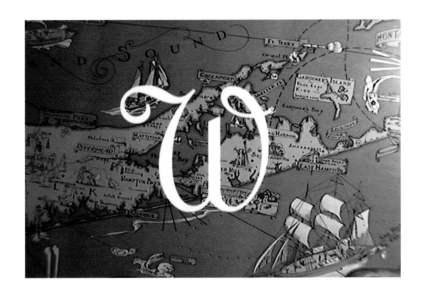

I decided to monogram

eastern Long Island.

The island forks

like a fishtail

into the Atlantic Ocean.

The local bus company

runs a line from

Orient Point to Montauk Point,

a long "U"-shaped journey.

I rode roundtrip making

two "U"-shaped bus trips.

Or, a double "U."

My monogram.

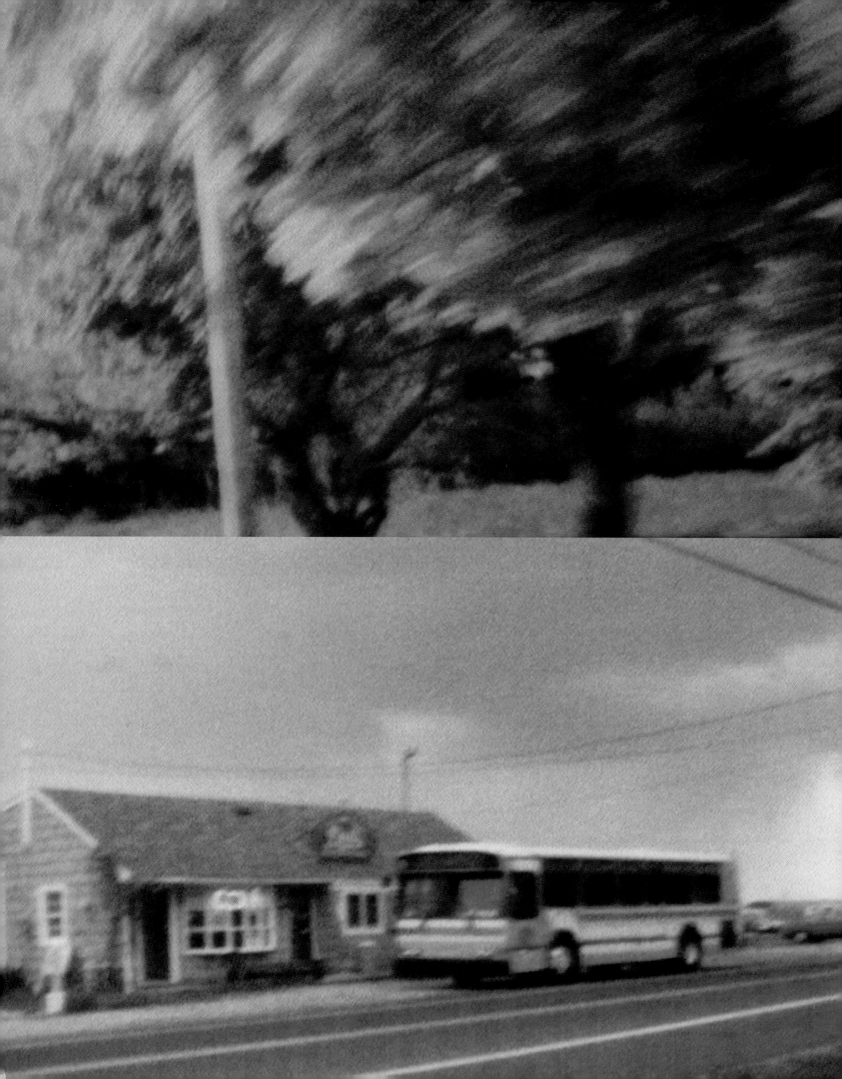

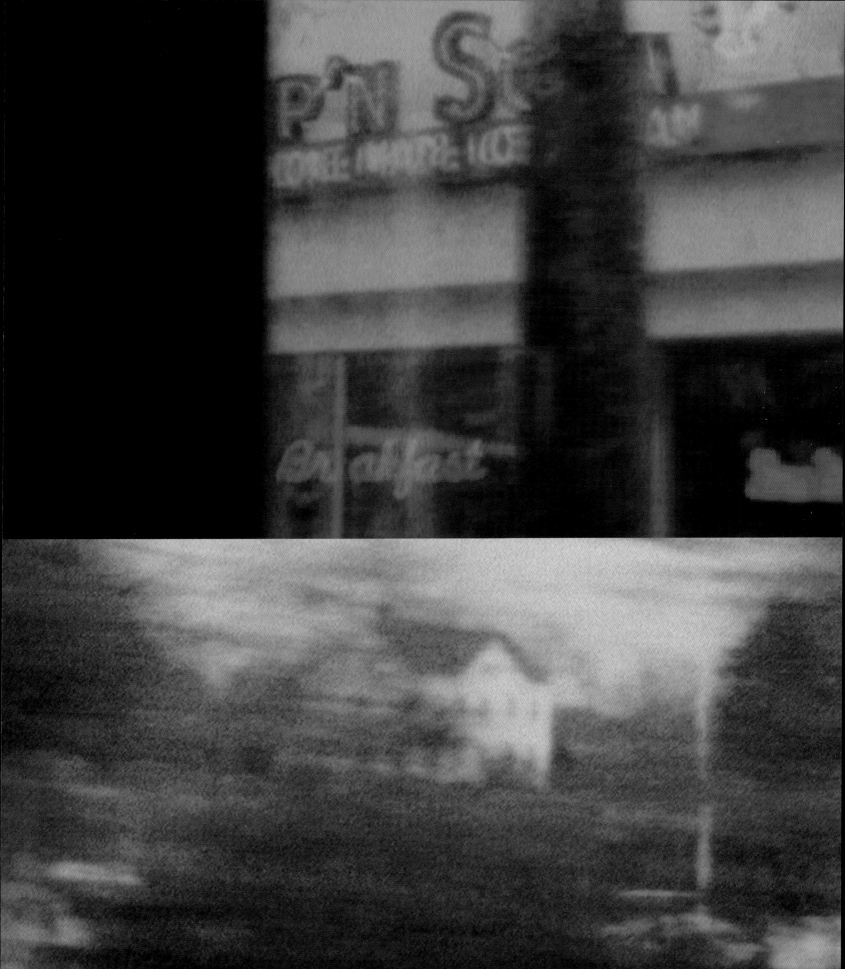

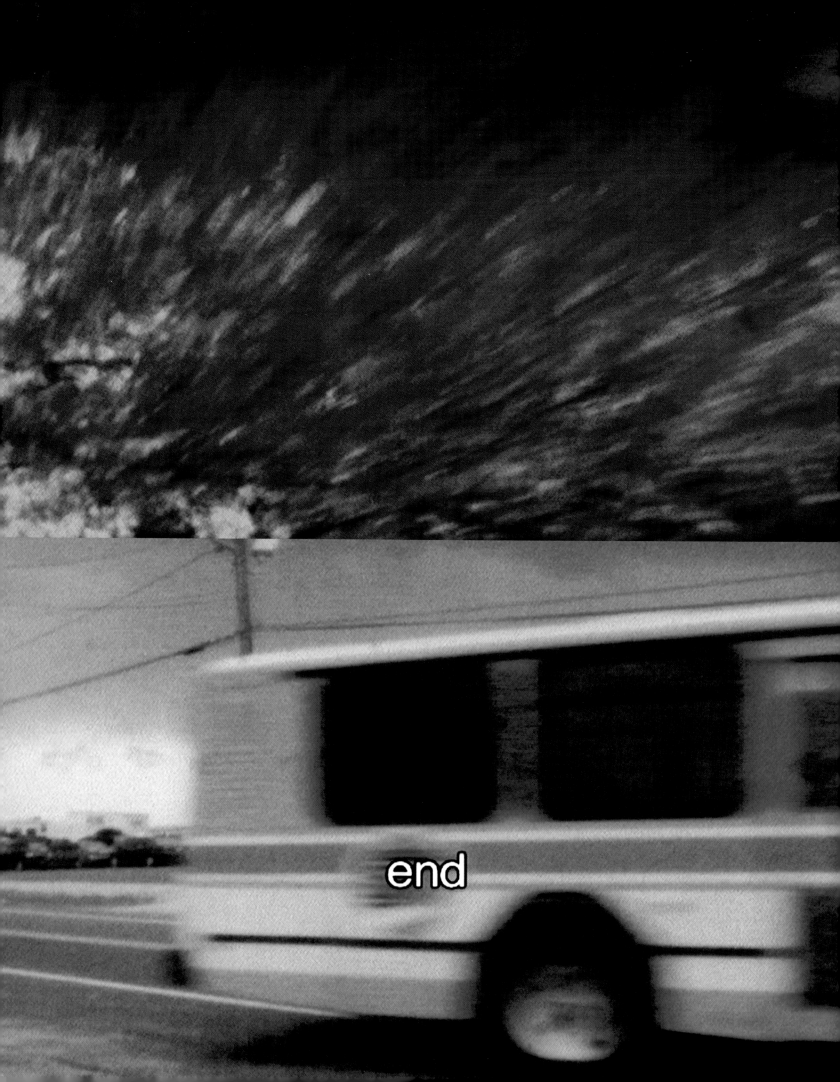

SUNSET

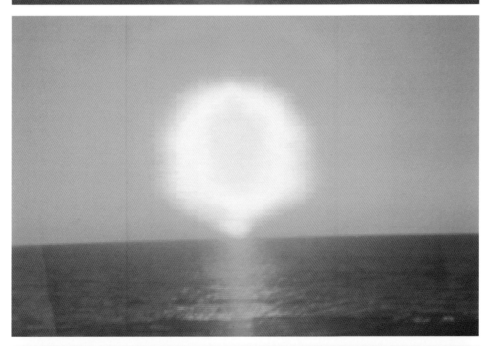

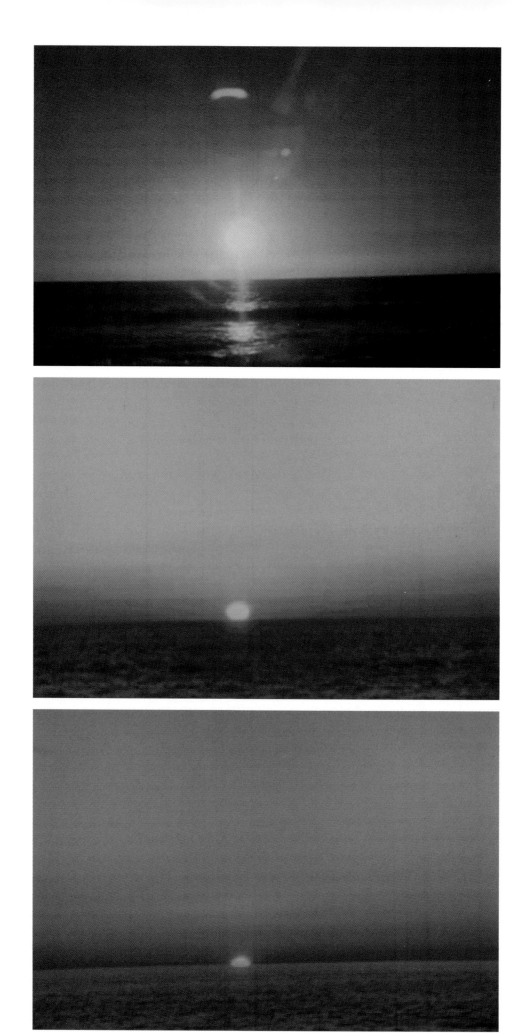

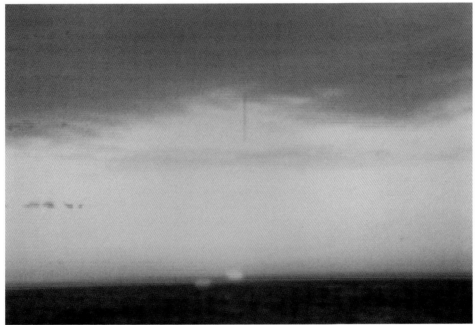

GARLAND FOUR
 Alpine Christmas
 Blind Painter
 Rodeo Queen
2005, 16mm film, 8 minutes, 33 seconds

Garland Four

ALPINE CHRISTMAS

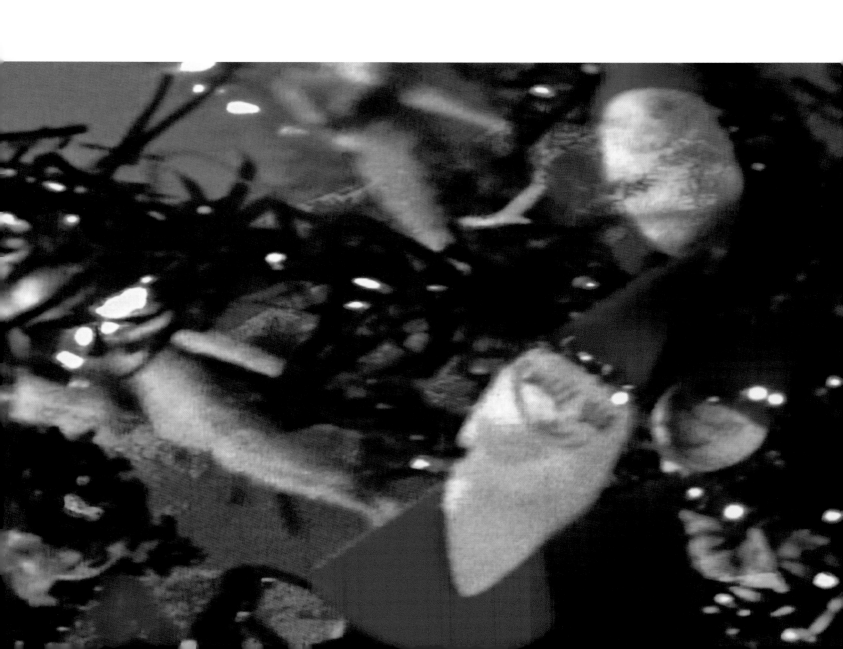

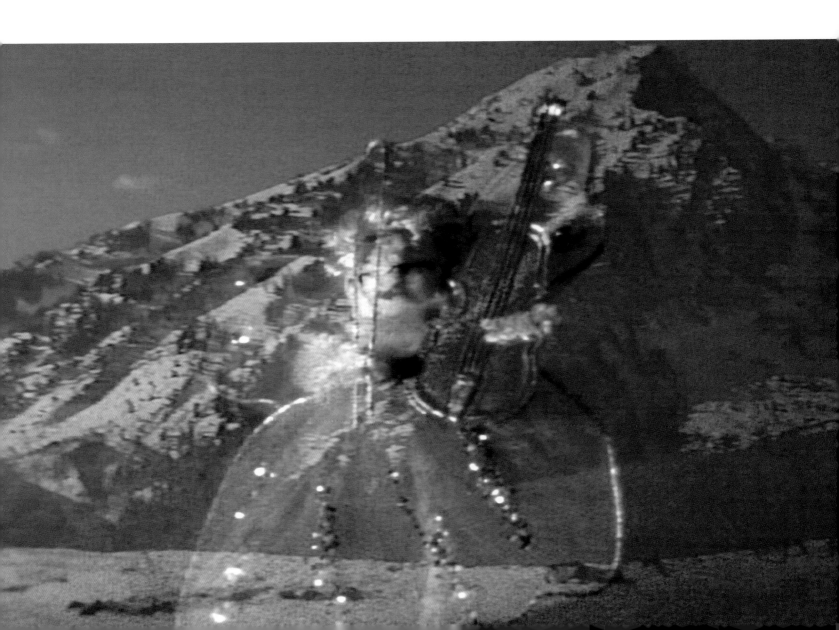

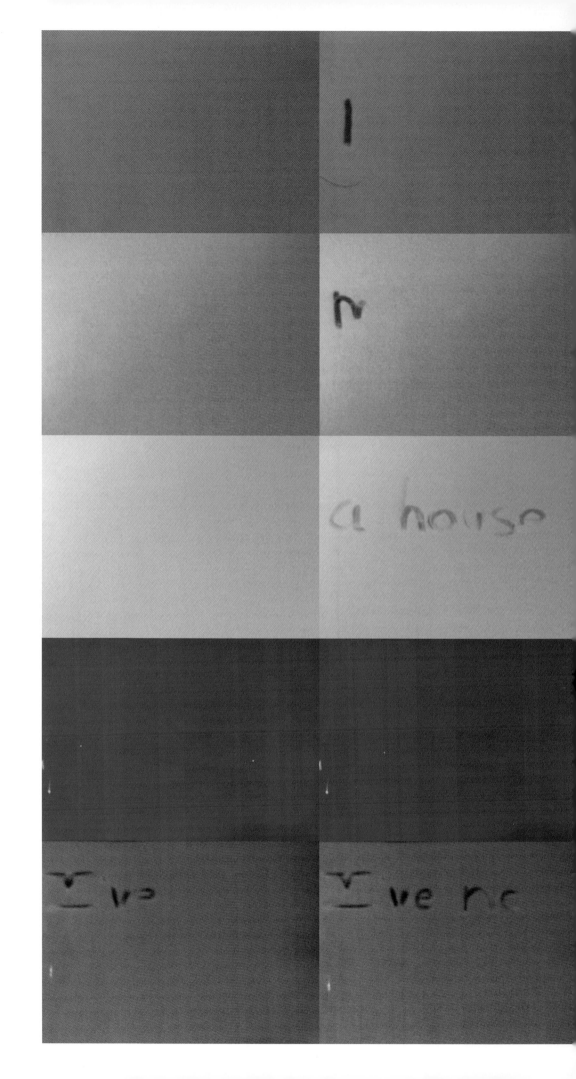

In 1972

my Mom hired

a house painter

who was deaf

I've never forgotten

	wa	watching
	wi	with the
	writing	writing thei
	in	in the
o	on my	on my
	h	bedro

watching them ta'

with their fing

writing their thou

In the fresh

on my bedroom wa

watching them talk

with their fingers

writing their thoughts

In the fresh paint

on my bedroom wall

RODEO QUEEN

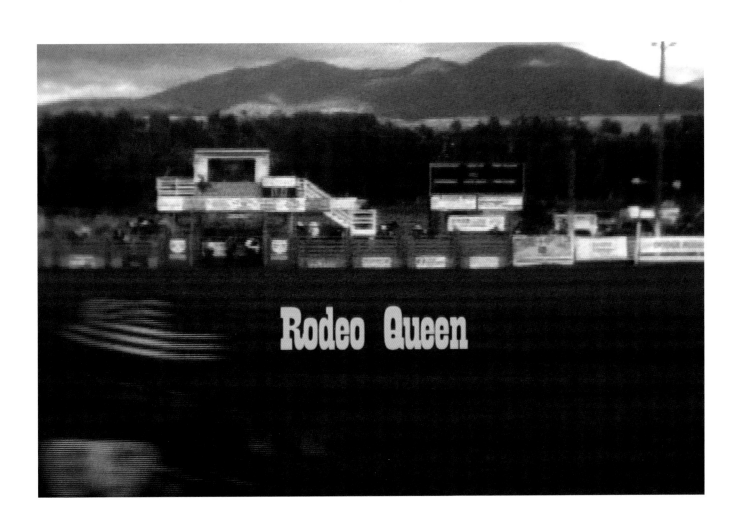

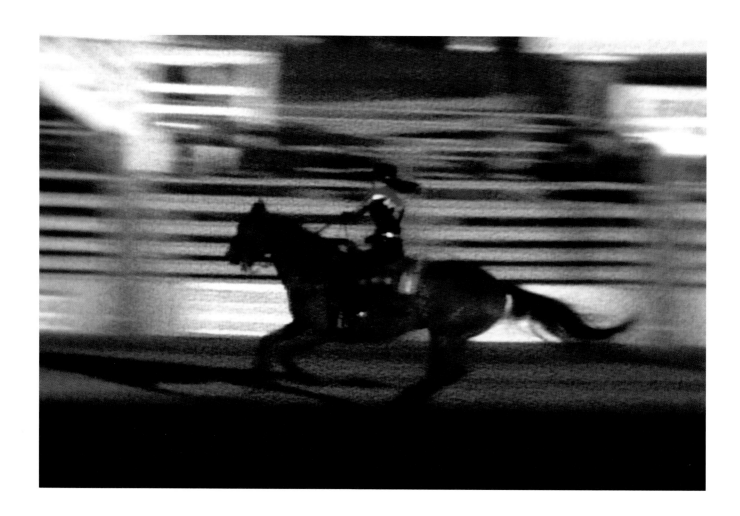

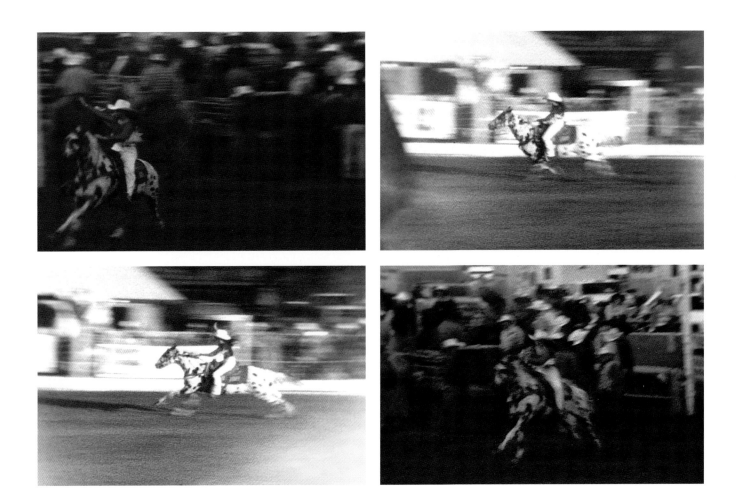

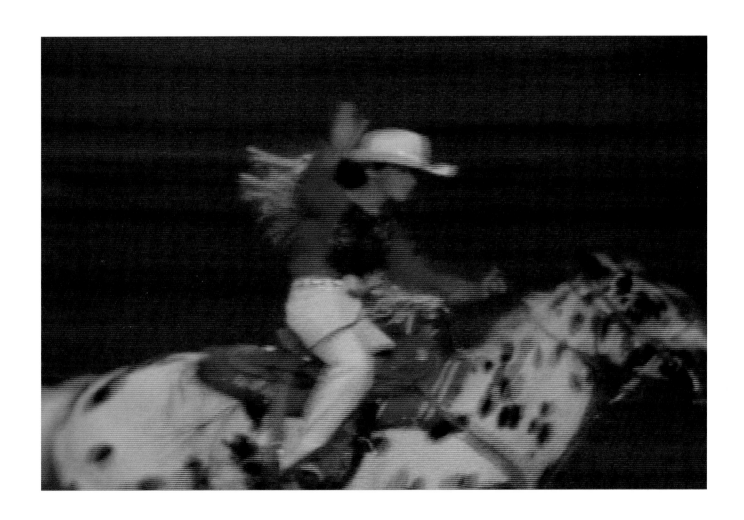

GARLAND FIVE
La Comtesse de Castiglione
Chopin
Pamela Digby Churchill Hayward Harriman
2005, 16mm film, 6 minutes, 49 seconds

Garland Five

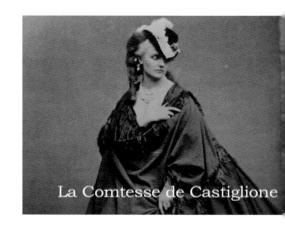
La Comtesse de Castiglione

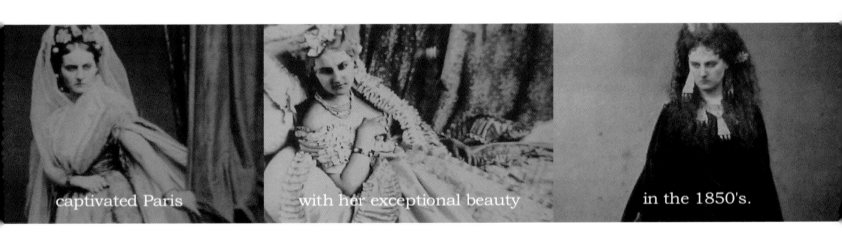

captivated Paris with her exceptional beauty in the 1850's.

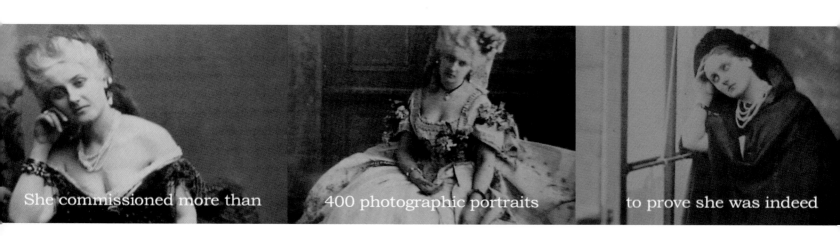

She commissioned more than 400 photographic portraits to prove she was indeed

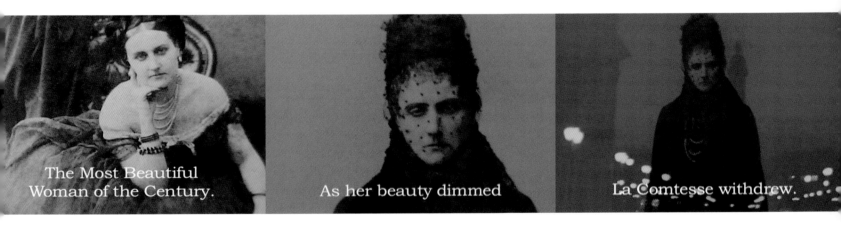

The Most Beautiful
Woman of the Century.

As her beauty dimmed

La Comtesse withdrew.

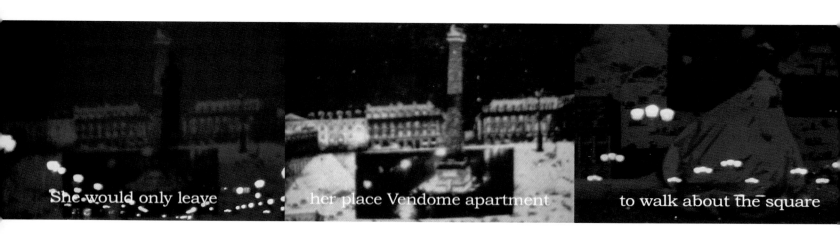

She would only leave her place Vendome apartment to walk about the square

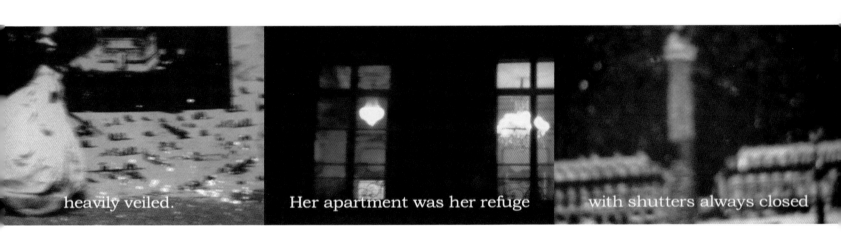

heavily veiled. Her apartment was her refuge with shutters always closed

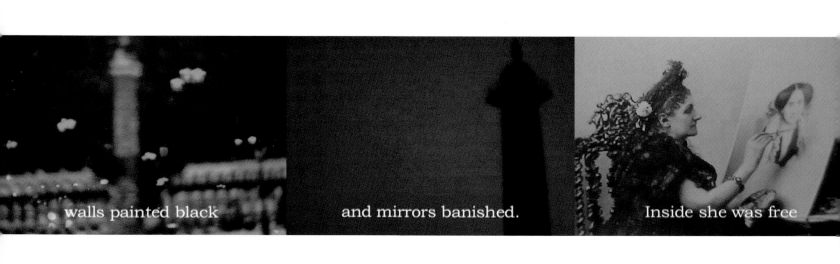

walls painted black and mirrors banished. Inside she was free

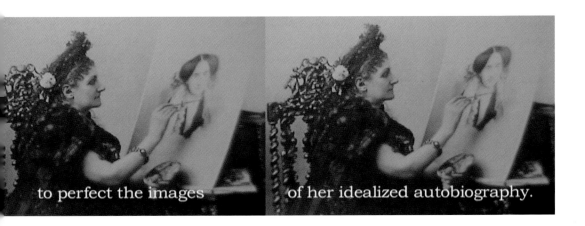

to perfect the images of her idealized autobiography.

CHOPIN

In the fall of 1849 a gravely ill Chopin was moved to 12 Place Vendôme.
It was hoped that luxury might restore and console him.

Though widely admired he was penniless and pursued by creditors.
Abandoned by his lover, George Sand, he was dying of consumption.

On his final afternoon Chopin's favorite performer was summoned to play and sing.
She had just begun when, overcome with emotion, Chopin motioned her to stop.

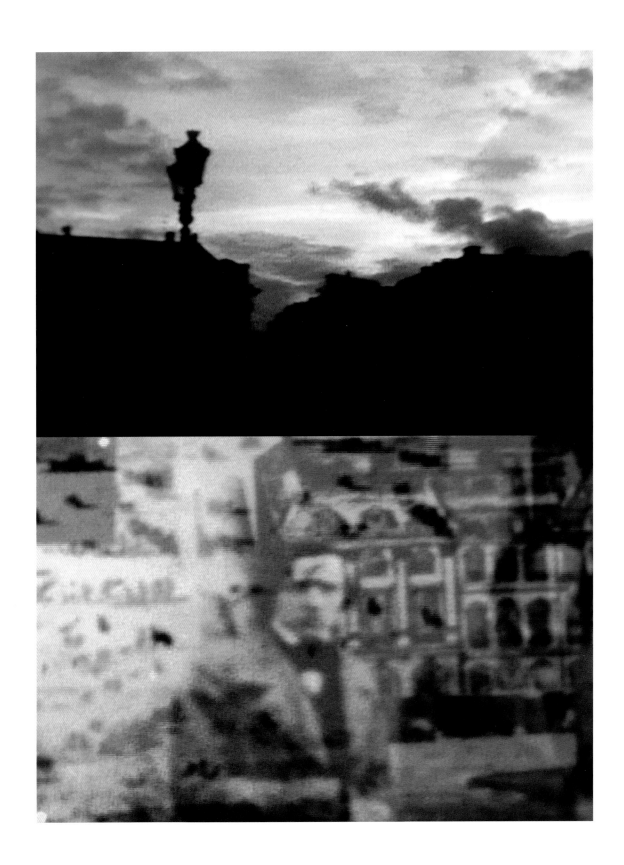

Shortly thereafter his gaze tarnished.

Chopin had expired.

PAMELA DIGBY CHURCHILL
HAYWARD HARRIMAN

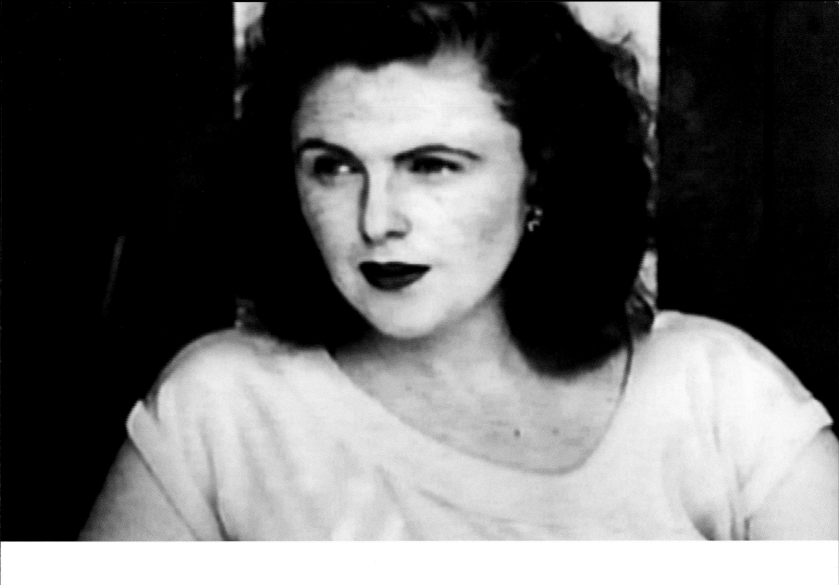

Happily separated
from her first husband
and 25 years old,

Pamela Digby Churchill Hayward Harriman

chose post-war Paris

as a glittering backdrop

for a fresh start.

Frank Sinatra
Gianni Agnelli
Randolph Churchill
Aly Khan
Edward R. Murrow
Averell Harriman
Leland Howard
Elie de Rothschild
Jock Whitney

Her serial romances
define an exclusive club.

Her lifelong cultivation
of powerful friends
was spectacularly rewarded in 1993
with her appointment
as American Ambassador to France.

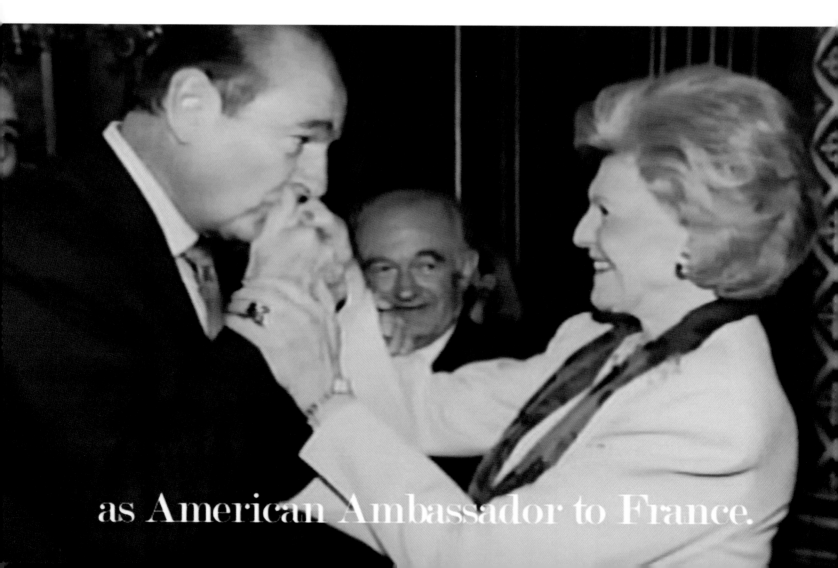

as American Ambassador to France.

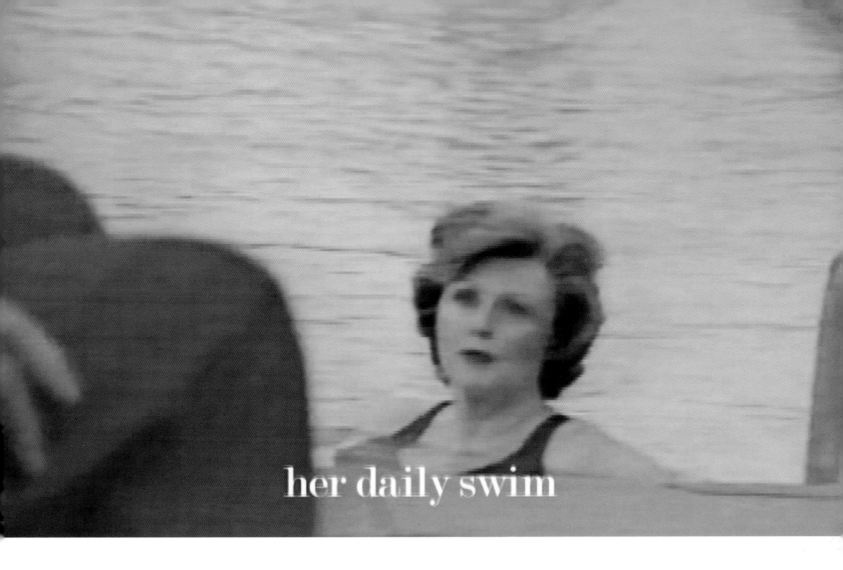

her daily swim

Madame Ambassador

was enjoying

her daily swim

at the Ritz Hotel

on Place Vendôme

when a fatal stroke
brought a premature end
to her finest hour.

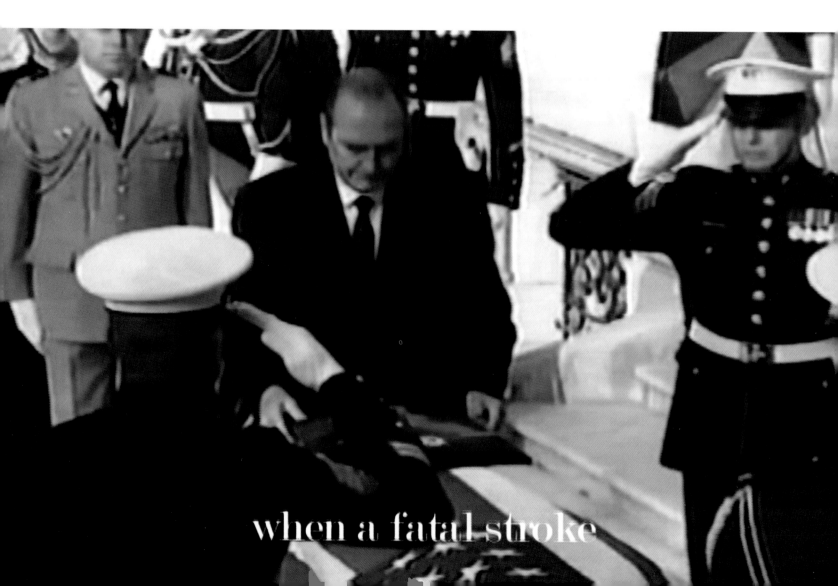

when a fatal stroke

GARLAND SIX
Kitties
Fall Swallows
Swan Song
2005, 16mm film, 9 minutes, 13 seconds

Garland Six

The island of San Lazzaro
lies near the famous shore
known as the Lido
on the Venetian lagoon.

La Serenissima
gave this little island to the
Armenian Mekhitarist monks
exhiled from Crete
by the Turks
in the seventeenth century.

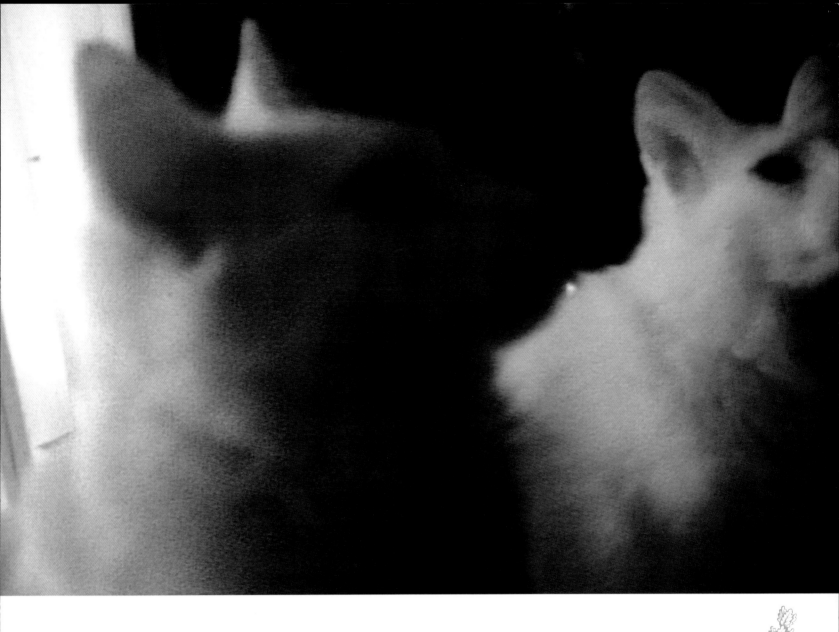

The Melchite Friars
their "beards the colour of meteors"
(wrote Byron)
are guardians of manuscripts;
all that remains
of a great civilization.

I feel grateful to them
for being the first
importers of angora cats
to the West.

FALL SWALLOWS

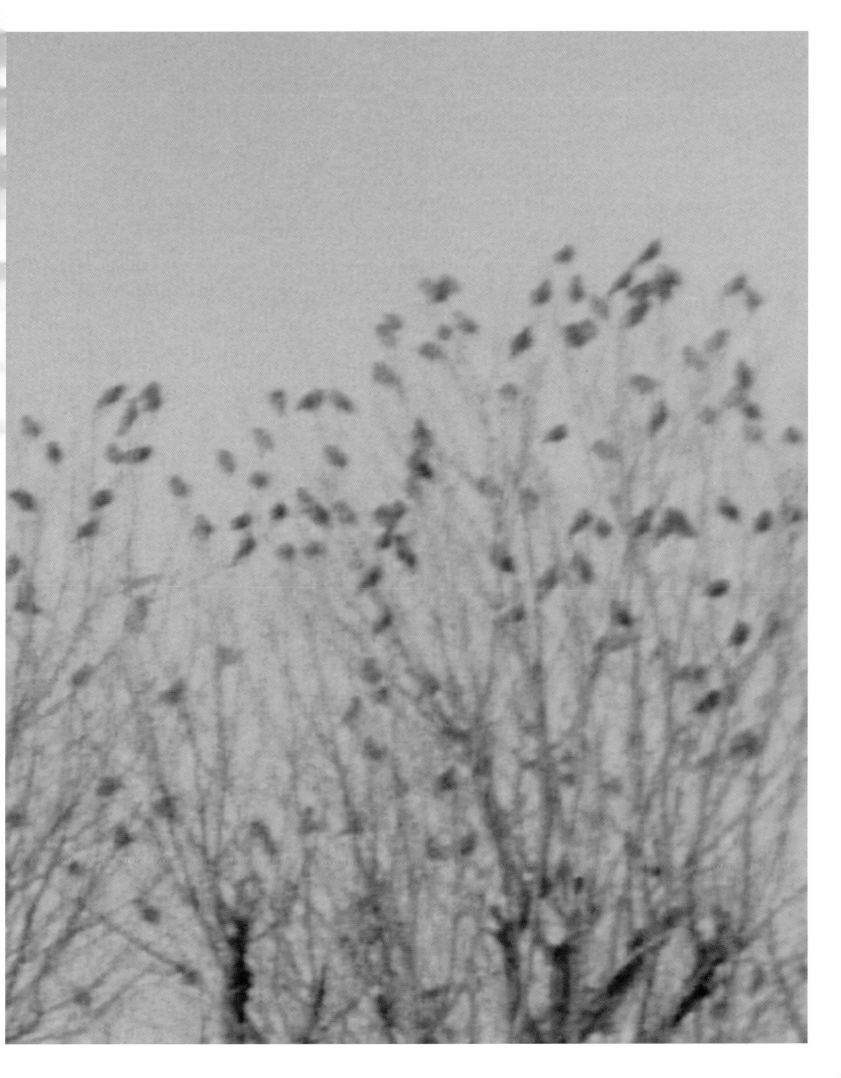

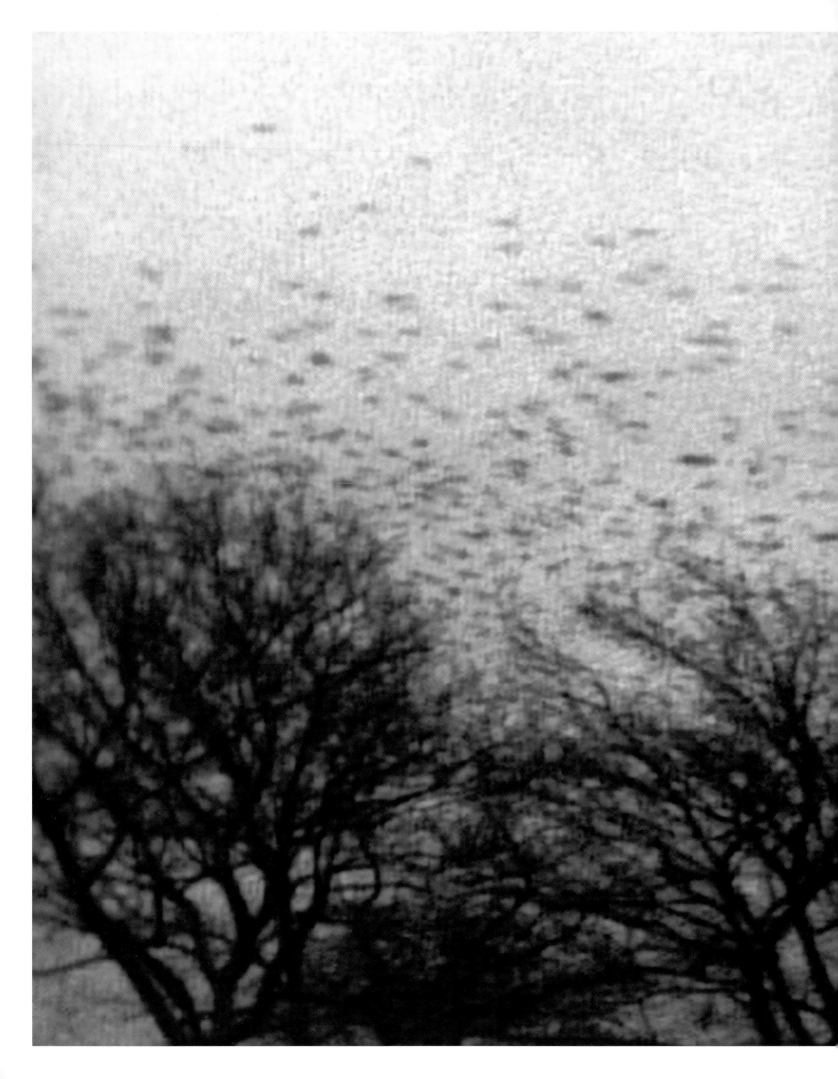

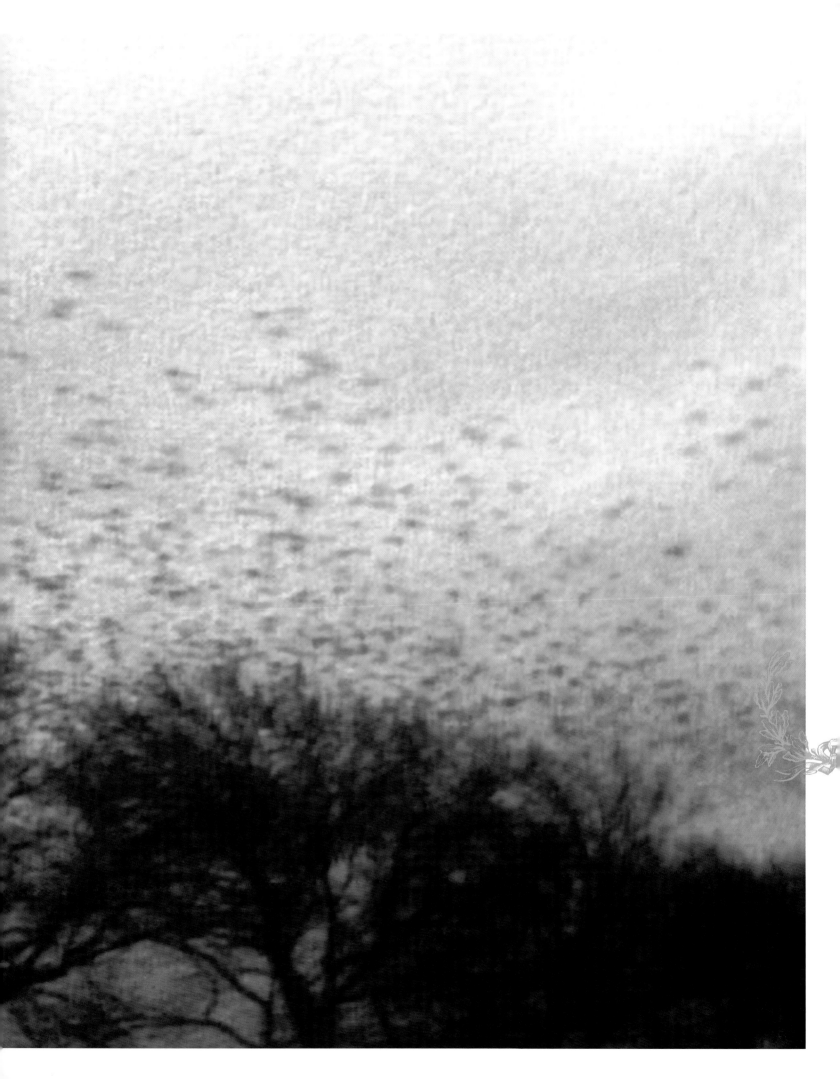

SWAN SONG

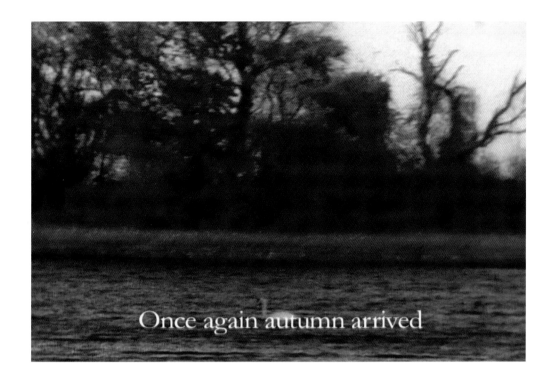

Once again autumn arrived

Once again autumn arrived
on Long Island
where I live.
The dog and I were enjoying
an afternoon walk
when we noticed the approach
of our neighbor, Beverly.
A typical conversation
with Beverly
is as cheerful
and straightforward
as her appearance.

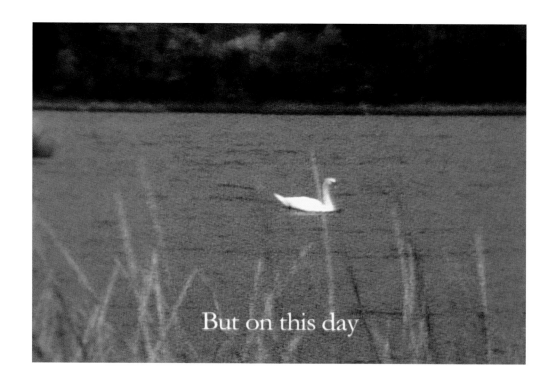

But on this day

But on this day
she seemed somber.
Beverly asked if I'd known
her dear friend Jean,
now deceased,
who until recently
navigated our neighborhood
in a wheelchair.
On hearing I'd never met her friend
Beverly began to describe
her many fine qualities.

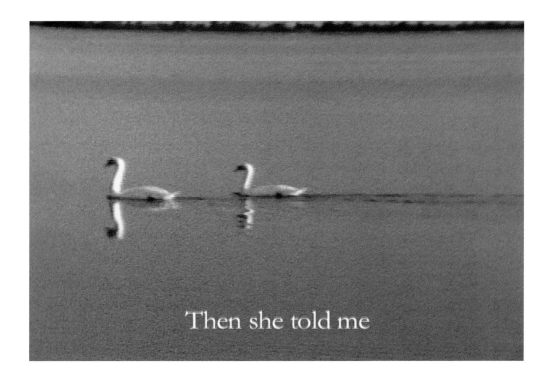

Then she told me

Then she told me
of Jean's "special gift".
Jean was clairvoyant
Beverly explained
and possessed the ability
to communicate
with the swans
which live in the estuaries
surrounding our coastal village.
It was the swans' foretelling
Jean could decipher.
Beverly would help Jean
to maneuver her chair
to the water's edge
so that Jean might seek
the swans' counsel.

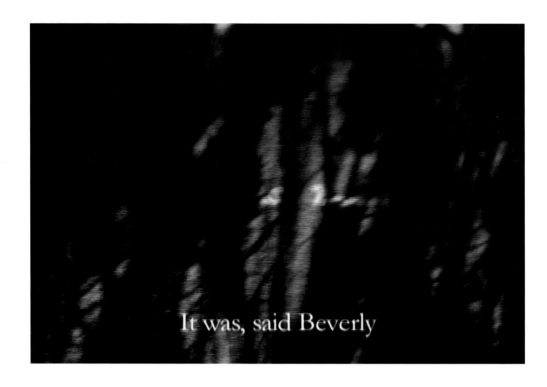

It was, said Beverly

It was, said Beverly,
the cumulative effect
of the swans' predictions,
often dire,
which made her
increasingly anxious
as each came to pass.
Apparently now
Beverly was emboldened
to unburden herself completely.
She confessed that
Jean had revealed
a final prediction
shortly before her death.

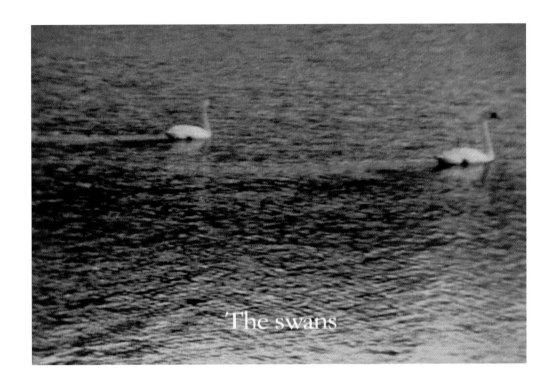

The swans

The swans
are anticipating
the end of the world.
Moreover,
they have a date.
Sometimes I wish
I had kept walking
at the sight of Beverly
that afternoon.
But I didn't
and now I'm left
with unwelcome news.

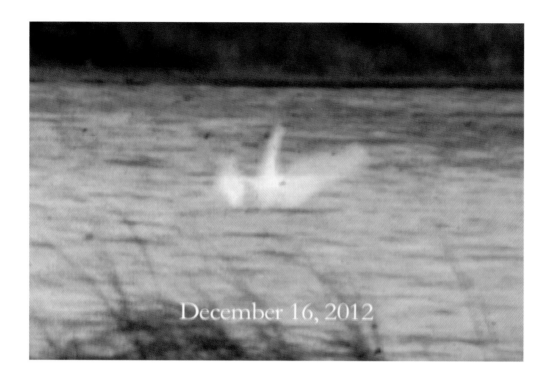

December 16, 2012

According to the swans,
December 16, 2012
is a date to remember.

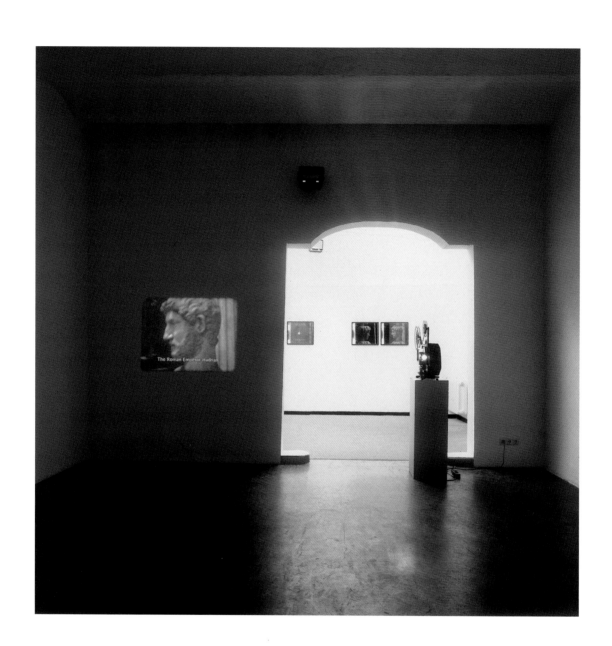

The Roman Emperor Hadrian

FILMS

1996 2000

THE ESCAPE OF
MARIE ANTOINETTE

1996, 16mm film, 12 minutes

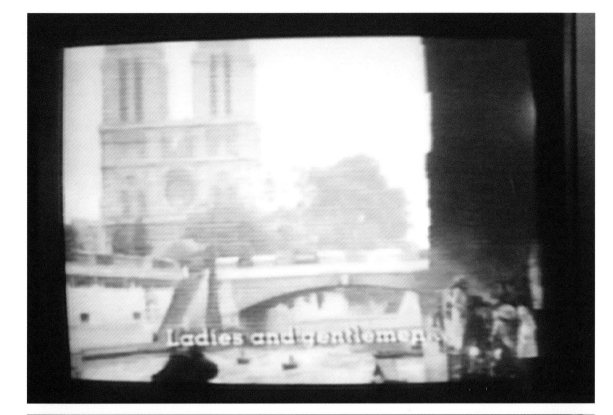

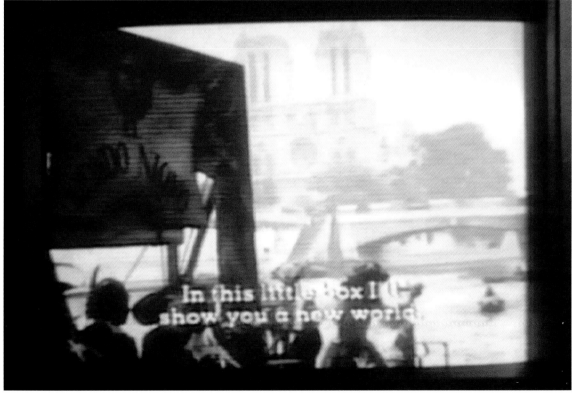

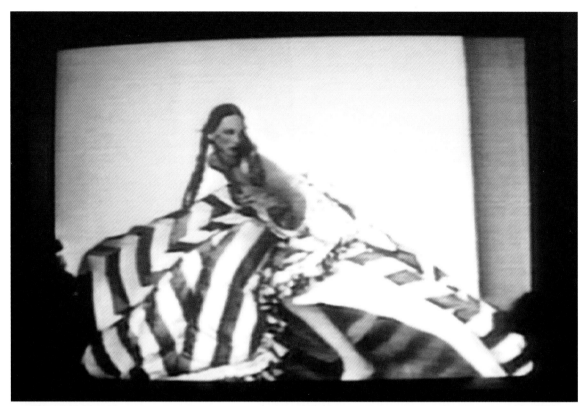
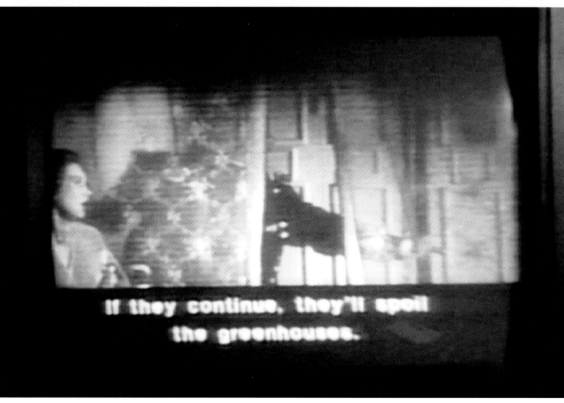

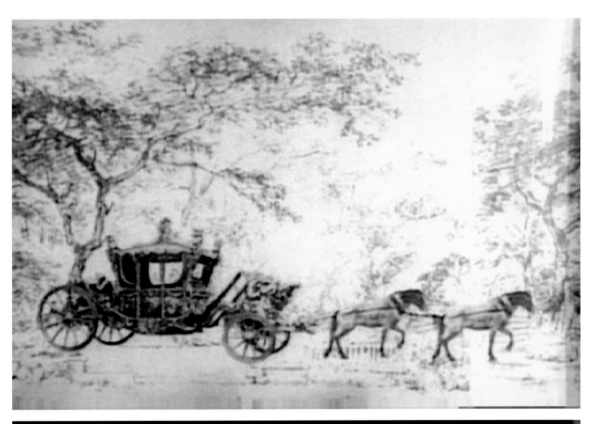

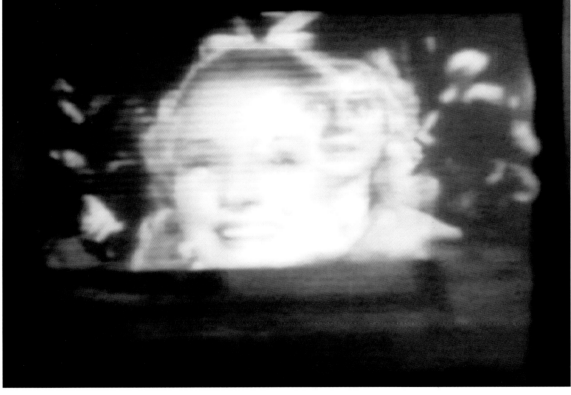

THE DEATH AND BURIAL OF THE FIRST EMPEROR OF CHINA

1997, 16mm film, 11 minutes, 44 seconds

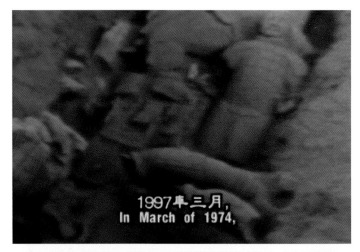

1997年三月,
In March of 1974,

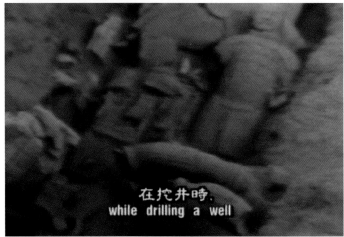

在挖井時,
while drilling a well

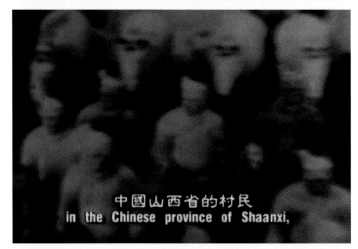

中國山西省的村民
in the Chinese province of Shaanxi,

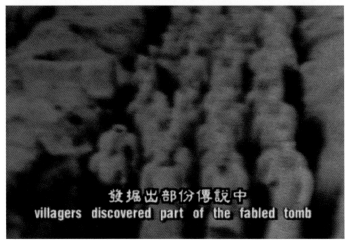

發掘出部份傳說中
villagers discovered part of the fabled tomb

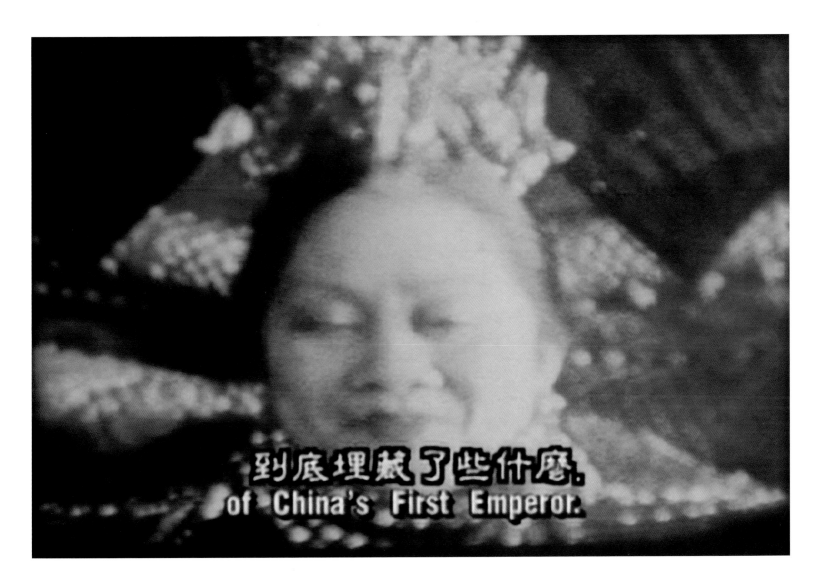

到底埋藏了些什麼.
of China's First Emperor.

早期的歷史學家
Early historians

形容秦始皇墓內
describe the interior of the Emperor's tomb

是一個複雜的. 自給自足的世界.
as an intricate self-contained universe.

被畫成夜晚的天空.
the painted ceiling portrays the night sky.

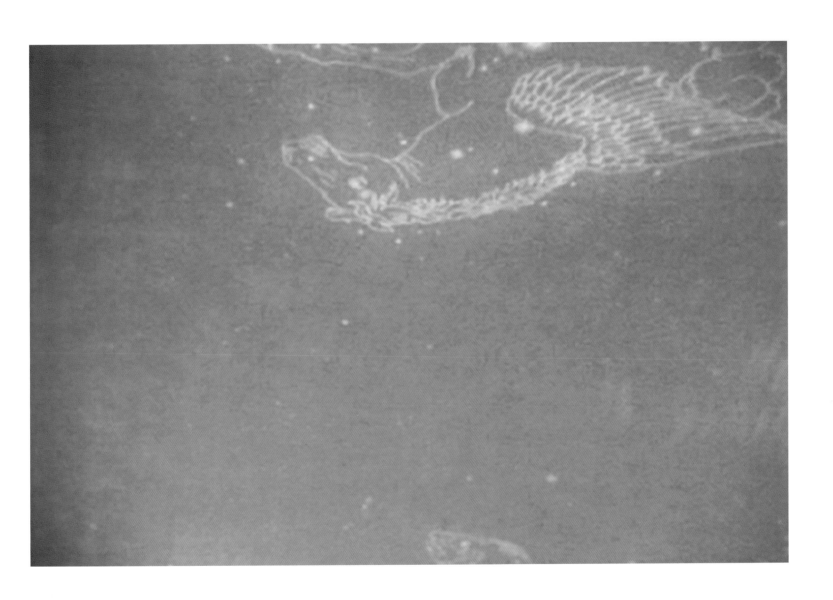

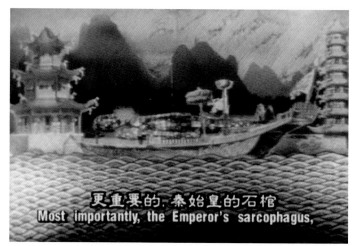

更重要的，秦始皇的石棺
Most importantly, the Emperor's sarcophagus,

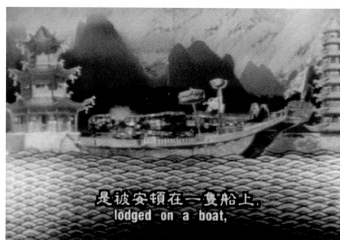

是被安頓在一隻船上，
lodged on a boat,

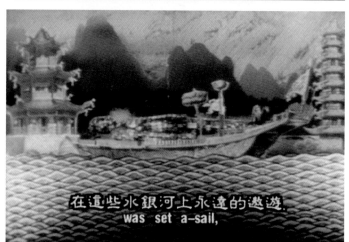

在這些水銀河上永遠的遨遊，
was set a-sail,

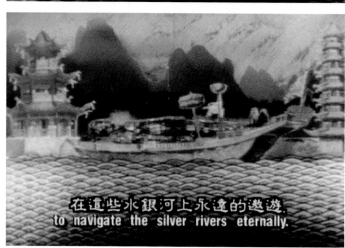

在這些水銀河上永遠的遨遊，
to navigate the silver rivers eternally.

STEPHEN TENNANT
HOMAGE

1997, 16mm film, 13 minutes

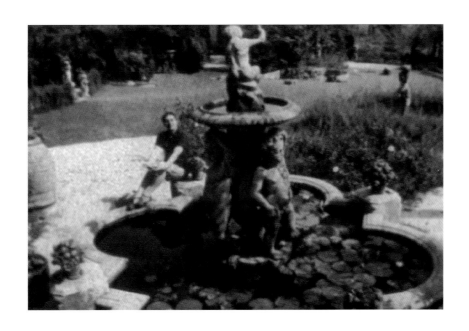

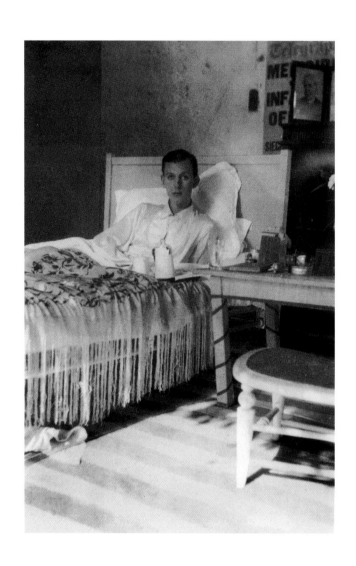

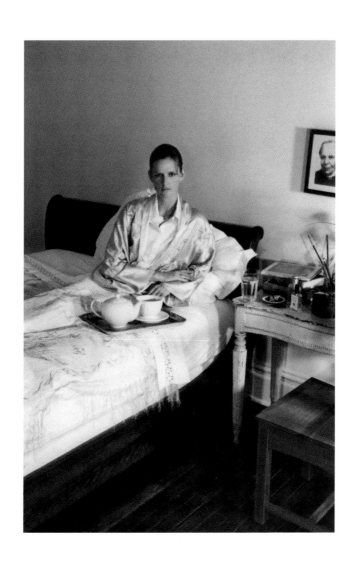

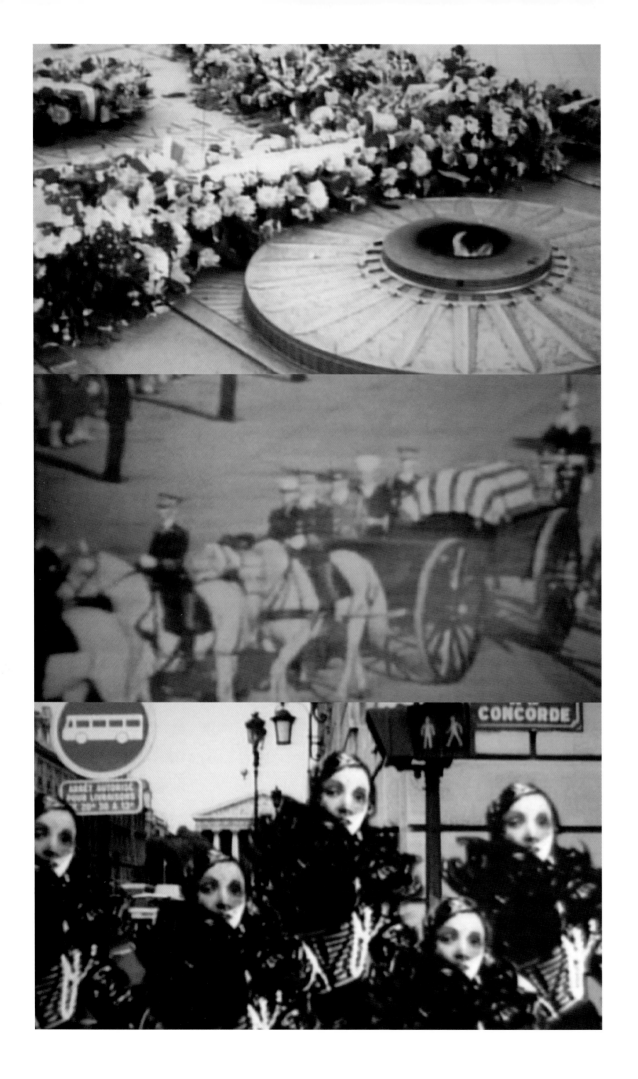

THE FUNERAL OF MARLENE DIETRICH

1999, 16mm film, 12 minutes, 30 seconds

Das Begräbnis der Marlene Dietrich

Könnt ihr euch den Rummel vorstellen, wenn ich tot bin? … Die Journalisten! Die Fotografen! Die Fans! De Gaulle wird einen Nationalfeiertag einsetzen. In Paris wird es keine Hotelzimmer mehr geben. Natürlich wird sich Rudi um alles kümmern. Er wird das *gern* tun! Nellie und Dot Pondell werden kommen und mich herrichten, Make-up und Haare. Vor lauter Tränen können sie nichts sehen, aber sie wissen sowieso nicht, was sie tun sollen. Die ganzen Jahre bei Paramount haben sie nie etwas tun müssen, weil ich alles selbst getan habe! Und jetzt bin ich nicht mehr da, es für sie zu tun. Und da stehen sie nun heulend und fragen sich, was sie mit den falschen Augenwimpern anfangen sollen und wie meine Haare vorne richtig legen. Hinten ist es egal, ich liege ja auf dem Rücken.

Jean Louis ist den weiten Weg aus Hollywood gekommen, und er ist wütend. Er hat gehofft, mich endlich einmal in das Mieder zu tun – und da sagt ihm Rudi, er lässt nicht zu, dass man seine Frau «in so einem Aufzug» sieht. Statt dessen werde ich ein einfaches schwarzes Kleid von Balenciago tragen. Rudi sagt das nur, weil er *weiss*, wie gerne ich es gehabt hätte, wenn ich einmal auf der Bühne ein kleines schwarzes Kleid hätte tragen können … Wie die Piaf.

De Gaulle wollte mich neben dem Grabmal des Unbekannten Soldaten am Arc de Triomphe beerdigen lassen und den Trauergottesdienst in Notre-Dame abhalten. Aber ich sagte nein, ich will den Gottesdienst in La Madeleine. Das ist meine Lieblingskirche in Paris, und die Chauffeure können ihre Wagen auf dem Hof nebenan parken und bei Fauchon Kaffee trinken, während sie warten.

Wir bekommen einen dieser Militärwagen, so wie ihn auch Jack Kennedy hatte. Sechs schwarze Pferde ziehen den Sarg, auf dem eine Trikolore liegt, geschneidert von Dior.

Die Trauerprozession zieht sich von der Place de la Concorde langsam den Boulevard de la Madeleine hinauf, den ganzen Weg bis zur Kirche, und die gesamte Fremdenlegion marschiert zum Schlag einer einzigen Trommel … Schade, dass Cooper tot ist, er hätte das Kostüm aus *Marokko* tragen und mitmarschieren können … Die Strassen sind gesäumt von Menschenmassen, die lautlos weinen. Die grossen Modehäuser haben geschlossen, damit die kleinen Verkäuferinnen und Näherinnen die Parade bestaunen und «Madame» ein letztes, tränenersticktes Adieu hinterherhauchen können. Aus der ganzen Welt haben sich die Schwulen eingefunden. Sie drängen durch die Massen und wollen näher an die strammen, schönen Fremdenlegionäre herankommen. Alle haben sich Kostüme aus meinen Filmen kopiert. Mit ihren Federboas und kleinen, verschleierten Hüten sehen sie aus wie ich in *Schanghai Express* … Aus seinem Wagen sieht Noël ihnen sehnsüchtig nach und wünscht, sich unter sie mischen zu können, aber er weiss, dass er sich heute benehmen muss, und fährt weiter. Er hat eine Hommage an «Marlenah» verfasst, die er selbst in der Kirche verlesen möchte. Aber er ist verärgert. Beim Dinner am Abend zuvor hat Orson ihm gesagt, *er*, Orson, werde eine ganze Szene aus *Macbeth* geben, und Cocteau habe ihm verraten, *er* werde auch etwas rezitieren, etwas *sehr* Klassisches, und zwar auf Französisch.

Während ich unter Trauerbezeugungen die Avenue entlanggezogen werde, treffen die geladenen Gäste vor der Kirche ein. Rudi steht in seinem neuen, von Knize geschneiderten dunklen Anzug vor der Kirche und bewacht den Eingang. Auf einem Tisch vor ihm liegen zwei Schachteln mit weissen und roten Nelken. Jedem, der die Kirche betritt, überreicht er eine Nelke, eine rote für die, die mit mir geschlafen haben, weisse für die, die nur behaupten, es getan zu haben. Nur Papi weiss Bescheid.

Die Kirche ist überfüllt. Die Roten auf einer Seite, die Weissen auf der anderen. Wenn Blicke töten könnten … Du kannst dir vorstellen, alle, besonders die roten Frauen, wollen sehen, wer auch Rot trägt. Als Burt endlich mit der Ouvertüre anfängt, sind alle in der Kirche wütend aufeinander und furchtbar eifersüchtig, genauso, wie sie es immer waren, als ich noch lebte. Fairbanks kommt in einem Cutaway, mit einem Brief vom Buckingham Palast … Remarque schafft es erst gar nicht bis zur Kirche, er hat sich betrunken und die Adresse vergessen … Jean, eine Zigarette rauchend, lehnt in seiner Jeans vor der Kirche und weigert sich, hereinzukommen … In ganz Paris fangen die Kirchenglocken an zu läuten …

The Funeral of Marlene Dietrich

"When I am dead, can you imagine the to-do? ... The reporters! The photographers! The fans! De Gaulle will proclaim a national holiday. Not a hotel room to be had anywhere in Paris. Of course, Rudi is going to organize everything. He will *love* it! Nellie and Dot Pondel will arrive to get me ready, do the make-up and hair. They are both crying so hard, they can't see, and of course, don't know what to do anyway! All those years they were with me at Paramount, they never had to do anything because I did it all myself! Now, for once, I am not there to do it for them, and they stand sobbing, wondering how they are going to put on the false eyelashes and get the front of my hair right. The back doesn't matter because I am lying down.

"Jean Louis has come all the way from Hollywood and is furious! He thought for once he would get the chance to put me into my foundation for the stage dress—now Rudi tells him that he will not allow his wife to be "seen like that!" and that I am going to wear "a simple black dress from Balenciaga" instead. Rudi says that only because he *knows* how I always wished I could get away with wearing just a little black dress on the stage ... like Piaf.

"De Gaulle wanted me to be buried next to the Unknown Soldier at the Arc de Triomphe and do the service at the Notre-Dame, but I said, "No, I want it at the Madeleine." That is my favorite church in Paris and the chauffeurs can park their limousines in the square next door and go have a coffee at Fauchon while they wait.

"We get one of those army wagons, like the one they had for Jack Kennedy when he was killed, with six black horses to pull the coffin, which is draped in a special tricolor, made by Dior.

"The procession will start at the Place de la Concorde and make its way slowly, up the Boulevard de la Madeleine—all the way to the church, with the whole Foreign Legion marching to the beat of a single drum ... Too bad Cooper is dead, he could wear his costume from *Morocco* and join them ... The crowds line the streets, silently weeping. The great dress houses of Paris have closed their doors so that the little shop girls, the fitters, can go to the parade and say their last tearful adieux to 'Madame.' From all over the world, the Queers have arrived. They push through the crowds, trying to get closer to those rugged, handsome Legionnaires. For the grand occasion, they have copied costumes from my films and all look like me in *Shanghai Express* in their feather boas and little veiled hats ... From his car, Noel takes one look and wishes he could mingle but knows he has to be on his best behaviour—so doesn't stop. He has written a special tribute to 'Marlenah,' which, of course, he will recite at the church himself, but he is annoyed, because when he had dinner with Orson the night before, Orson told him that *he* was going to do a whole scene from *Macbeth* and that Cocteau told him *he* was reciting something too, *very* high class and—in French!

"While I am being marched and mourned up the avenue, the invited guests start arriving at the church. Rudi stands in his special, newly made by Knize, dark suit, guarding the entrance. On a table in front of him are two boxes filled with carnations—one with white ones, one with red. As each guest enters the church, Rudi gives him, or her, a carnation to wear—Red for those who made it, White for those who say they slept with me but never did. Only he knows!

"Inside, the church is crowded. The Reds on one side, the Whites on the other. They are all looking daggers at each other! You can imagine, everyone trying to see who has red, especially the women ... By the time Burt starts my overture, everyone is furious, madly jealous of each other, just like they always were when I was alive! Fairbanks arrives in a cutaway, bearing a letter from Buckingham Palace ... Remarque never makes it to the church—he is drunk somewhere and forgot the address ... Jean, smoking a Gauloise, leans against the side of the church—refuses to go inside ... All over Paris church bells begin to peal..."

THE LITTLE ELEPHANT

2000, 16mm film, 4 minutes, 38 seconds

In the great forest

a little elephant is born.

His mother loves him very much.

She rocks him to sleep

with her trunk

while singing softly to him.

The little elephant is riding happily

on his mother's back

when a wicked hunter,

hidden behind some bushes,

shoots at them.

The hunter has killed

the little elephant's mother!

The monkey hides,

the birds fly away,

the little elephant cries.

The little elephant runs away

because he is afraid.

After several days,

very tired indeed,

he comes to a town ...

He hardly knows

what to make of it

because this is the first time

that he has seen so many houses.

So many things are new to him!

The broad streets!

The automobiles and buses!

However, he is especially interested

in two gentlemen

he notices on the street.

He says to himself:

"Really, they are very

well dressed.

I would like to have

some fine clothes, too!

I wonder how I can get them?"

Luckily, a very rich Old Lady

who has always been fond

of little elephants

understands right away

that he is longing for a fine suit.

As she likes to make people happy,

she gives him her purse.

The litttle elephant says

to her politely:

"Thank you, Madam."

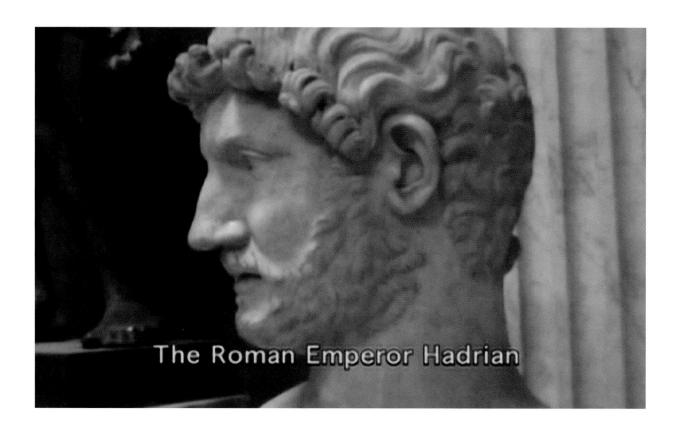

The Roman Emperor Hadrian

The Roman Emperor Hadrian
loved a Greek boy, Antinous,
and the story of their passion has withstood 18 centuries
of misunderstanding, controversy, and Christian polemic.

Antinous was a young man of 13
when Hadrian met him on a trip to Greece.
To the Emperor, the boy was the physical embodiment
of the perfection he sought in all things.
Their union changed the course of his life
and became his great obsession.

Hadrian's reign (117–138 AD) ranks among the greatest epochs
in the thousand year history of Imperial Rome.
It is said he sought to rig his country like a fine ship
made ready for a voyage that might last for centuries.
It is certain that his reign saw prosperity, civic stability
and an exceptional flourishing of the arts.

Hadrian sought to encourage in man the sense of the divine,
but to do so without sacrificing
what is essentially human.

HADRIAN AND ANTINOUS

2000, 16mm film, 9 minutes, 49 seconds

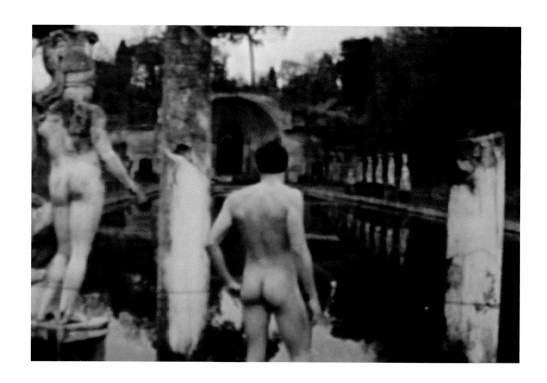

A lifelong philhellene,
he found in the ancient Greek culture
a utopian ideal, which matched his inclinations
and gave direction to his aspirations for the Empire.
His ideal was contained in the word "beauty,"
so difficult to define
despite the evidence of our senses,
and he felt responsible
for sustaining and increasing beauty in the world.
Yet, this passion
was matched with an elusive and remote personality.
The only person who seems
to have profoundly connected with him
was Antinous.
Something in the Greek youth
satisfied deep needs in the nature of the Emperor.

Antinous' beauty became legendary in his lifetime
and set a new masculine archetype,
yet that beauty must have worked in concert
with promise and spirit and unsullied idealism
to have captured and held the love
of the ruler of the Western world.
With him,
Hadrian's tortured personality attained serenity.

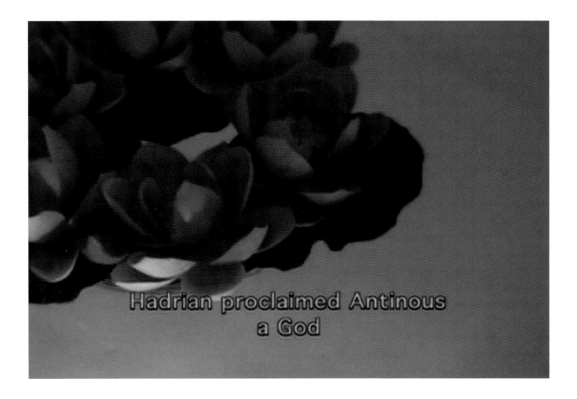

Hadrian proclaimed Antinous
a God

Inseparable, Hadrian and Antinous traveled extensively
for the next seven years,
visiting most of the vast Roman Empire.
Intrigued by the occult, they sought the advice
of magicians and soothsayers wherever they went.
Just before a trip up the Nile by royal barge,
they called on the ancient priesthood of Egypt,
soliciting their expertise in magic, astrology, and predictions.

They were told of the power of the Nile,
which was thought to confer immortality
on those who drowned there,
and from which the god Osiris had risen.

The trip, undertaken in a spirit of adventure and pleasure,
took a turn for the worse.
Hadrian became gravely ill.
The magicians of the Nile
proposed a radical prescription.
Someone should die voluntarily
on behalf of Hadrian.
The belief that the voluntary death of one person
could save or restore the life of another,
or remove lethal dangers,
had firm roots in the minds and practice of antiquity.
It grew from the belief
in the regenerative power of love, freely given.

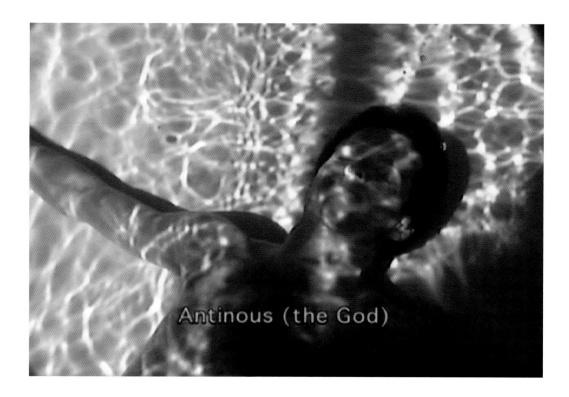

Antinous (the God)

Antinous offered himself to the Nile.

Hadrian reacted with all consuming despair.

The priests of Osiris accorded Antinous' corpse
the most secret and sacred burial rites,
including full mummification.
In the days following the death,
Hadrian proclaimed Antinous a God
and consecrated what would become a lavish city in his honor
at the desolate place on the Nile
where he offered himself.
On the banks of the Nile,
wreathes of the rosy lotus,
a bloom symbolizing the mystic marriage of Osiris and Isis,
were thrown on the water
in homage to the new God.

His public and formal divination was considered exceptional
considering his humble origins.
The full-scale apparatus of an Antinous cult flourished
with temples and priests,
oracles and mysteries,
games and a carefully developed myth.
Though physically and mentally shattered,
Hadrian tirelessly promoted the cult of his beloved
until he too died eight years later,
a broken man.

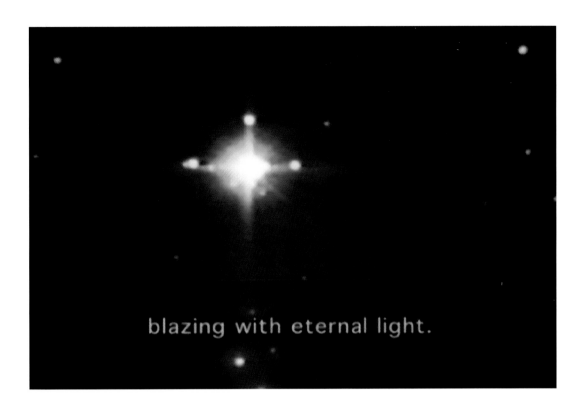

blazing with eternal light.

In Antinous
the ancient classical ideal of the divine immanent in man
received a final and spectacular affirmation.
Evidence of the belief in Antinous
and the regenerative powers of his self-sacrifice
have been found throughout the Roman Empire.
Hundreds of thousands of offerings left by pilgrims
near the site of his immolation have been discovered.
Like the new Christian faith,
Antinous (the God)
offered to other mortals the prospect of life eternal;
in him the old and the new forces
of religious experience briefly met.

Soon after Antinous' death,
Hadrian noticed a star
that was unknown to him in the night sky
and conferred with astrologers and mythologers
who assured him it was a "new" one.
Hadrian named it Antinous
and believed it to be his beloved's soul
blazing with eternal light.
Indeed, it shines in the night sky to this day,
still bearing his name
and undimmed by modern skepticism.

KILLING ME SOFTLY: THE FILMS OF T. J. WILCOX

JOHANNA BURTON

I. I LIKE, I DON'T LIKE

Jean Collet: What do you look for in making films?

Jean-Luc Godard: One looks first to satisfy an instinct. Something like the hunt for meat-eating animals, the need to create for an artist, a foot race for others. It is something very natural, a way of life for each individual. Inside this instinct, one looks for a certain truth. Something which one can express in a clear way, as being able to say, "This is good." Under a certain moral position, let's say the truth.[1]

It's always a bit overdetermined to start an essay with a quote from Godard, so I'll use this—the first lines of text-body—as a bit of a disclaimer. I don't see T. J. Wilcox as having so much in common with Godard (though the latter's claim that "I make my films not only when filming, but as I read, eat, dream, even as I talk,"[2] would surely appeal to the former). Or, perhaps I should say that Wilcox's work has plenty in common with Godard's but making a comparison would be deadly for all the obvious reasons. So, instead of offering superficial structural associations that I'm really unqualified to make, I'll offer the truth: I like the word instinct. I like the way that Godard suggests that film is made in the same way a lion sniffs out a deer, the way a pig roots out a truffle, the way some of us were constituted to run marathons, others to smoke two packs a day. I like that, for as theorized as Godard's work has been, he maintains the desire to "show—just show, not comment on—the moment when a feeling enters the body and becomes physiologically alive."[3] I like that Godard asks us *à la* Brecht, to question what we think we know and to insist on "rediscover[ing] everything about everything." I like that 40 years ago, he wrote, as a conclusion to his essay, "One or Two Things," that "There have been periods of organization and imitation, and periods of rupture. We are now in a period of rupture. We must turn to life again. We must move into modern life with a virgin eye."[4] I like that all of these Godard-*isms* make me think of T. J. Wilcox and I also like that I need to explain why.

While, at a glance, Wilcox's films—dripping with palpable nostalgia and romance—would hardly appear to assert a "move into modern life," they counterintuitively, instinctively even, function as the kind of eye-openers Godard might wish for.[5] (Insofar as this essay is concerned, it matters less whether the avant-garde god would sign on or not, actually: it matters more that I like the idea that he would.) For they impart a kind of gentle, even precious, trauma (a seeming oxymoron unless you've experienced it),

[1] 1963 interview with Jean-Luc Godard by Jean Collet, translated by Toby Mussman. First published in *Cinéma Aujourd'hui*, no. 18, Editions Seghers, Paris. Reprinted in *Jean-Luc Godard: A Critical Anthology*, ed. Toby Mussman, E.P. Dutton, New York 1968, p. 138.

[2] Jean-Luc Godard, "One or Two Things," translated by *Sight and Sound*. Originally published in *Le Nouvel Observateur* in 1966. Reprinted in *Jean-Luc Godard: A Critical Anthology*, p. 274.

[3] Ibid., p. 282.

[4] Ibid., p. 283.

[5] For an incisive discussion relating Wilcox's work to the collusion of film and romanticism, see Bettina Funcke, "T.J. Wilcox: From Dusk till Dawn," in *Afterall*, no. 12, p. 45–52.

a lulling melancholic delight, where fantasy works less to paper-over the bleakness of everyday life but, rather, emphasizes our various means of overcompensation all the more. This is not, by the way, to underestimate the pleasures of the everyday, of which Wilcox is nothing less than a connoisseur. But it is to point out the ways in which such pleasures move through our bodies with a resonance, a pitch, that feels uncannily like sadness (or perhaps a better way to describe it is *unexpected gravity*). And it is also to point out the ways in which the loftiest subjects—no matter how fabulous, no matter how well scripted—always find their reality effects in details: seemingly inconsequential, petty, particular eccentricities that escape neat narrative parameters. It is, last of all, an attempt to point out that some ruptures announce themselves in whispers, that they disrupt not through violence but, instead, by flirting, seducing, by singing siren songs.

It is easy to forget that film was argued early on as the medium that attends to the nearly unnoticed, the supplementary, the less-than-necessary. Yet, the emphasis on such "details"—rendered through effects including the close-up and slow motion—was seen not to render film an intimately personal experience but, quite oppositely, a public affair. Much of the conclusion of Walter Benjamin's iconic "The Work of Art in the Age of Mechanical Reproduction"—an essay which is usually discussed with regard to photography—is devoted to thinking about film in this way. Even while foregrounding the fact that film isolates and even makes visible what we might otherwise never see (writing that film "reveals entirely new structural formations"), Benjamin ultimately concludes that, in the 1930s at least, film is a perfect example of art that is received by the increasingly distracted audience that it, in effect, produces. Benjamin's is not—contrary to many theories of film—the positing of a purely submissive audience, one that sits in the dark and simply lets film happen around it. Film does, Benjamin admits, due to its speed and optical discombobulating effects, deliver corporeal shock and, thus, is capable of imparting a kind of passivity. But, modern audiences adapt, for better or for worse, as all audiences over time have done. Indeed, for Benjamin, the strange combination of shock and distraction produces an unexpected phenomenon. The public, *en masse*, comes to occupy the role of critic—imparting opinions, commenting on plot, largely applauding the conventional and deploring anything out of the ordinary. And this is the twist, since the modern critic Benjamin describes, for all his ostensible access to glimpses of the "new" in the everyday, comes to, instead, hardly pay attention at all. "The public is an examiner," he writes dryly, "but an absent-minded one."[6]

Some seventy years after "The Work of Art" essay was written, it is easy enough to see the ways in which film's odd ability to pro-

[6] Walter Benjamin, "The Work of Art in the Age of Mechanical Reproduction," *Illuminations*, ed. Hannah Arendt, Schocken Books, New York 1969, p. 241.

duce simultaneous shock and distraction has exponentially increased. (One need only visit any Loews multiplex to fall into the feeling—a kind of anesthetic haze that seems to heighten rather than lessen stimuli.) But what would a purely personal cinematic enterprise entail? How might a certain kind of film demand an audience of one (or two or three, but only as many as can stand in front of a painting, say)? And is it possible to argue for a different kind of shock, one that cultivates absorption, rather than distraction? Of course my answer is yes (rhetorical flair is funny this way—there would be no reason to pose the question if I weren't to answer in the affirmative). How does, that is to say, the shock of a soft touch take up inhabitance on-screen? Better, how does said soft touch move from screen to viewer and back again?

"Soft touch" implies a lover's touch (or maybe just the cliché of the lover's touch). But I'm maybe less interested in that touch or the fantasy of that touch, with all its baggage and eventual monotony: maybe what I'm getting at is more akin to something we could awkwardly call the *liker's* touch. We all know what we like, what we don't like—some things vehemently, passionately, with utter commitment; others fleetingly, or *hardly*, with the capacity for fickle reversal. But the funny thing about likes (as opposed to loves, or perhaps as a complication of them) is how particular they are, how *detail* oriented, how utterly dedicated to the miniscule, the seemingly unimportant. The liker's touch moves sporadically, it never lands on the same thing or in the same way twice. It is unstable, unabashed, enthusiastic, and childish. It is greedy, grumpy, indulgent, and irreverent of consequence. But, for however seemingly (and actually) superficial, the liker's touch is what drives the day-to-day (which quickly becomes the year-to-year)—it culminates in our "choices," and fuels our "beliefs." Professing one's likes and dislikes is not the pseudo-critical endeavor of absent-mindedness. It is, instead, an utter attentiveness to that which holds us in its grasp (however fleetingly).

But it's embarrassing to admit just how consequential the inconsequential can be. Are we creatures ultimately defined by today's obsession with who-knows-what? Would we be so reduced to our whims? In films that kill us softly, yes we are reduced to whims and precisely nothing less than whims—that is if we take our whims seriously. (Here's a whim now: please read the following footnote. It is not a supplement to the text, even if it is off to one side. In fact, it is absolutely the center of the text, which is *why* it is off to one side, and it is one of my favorite self-portraits of all time and a testament to the immanent ethics of "liking." I should be honest and say that I like it so much because I feel, when reading it, that it's my own list—to read it is to write it. What I don't like is that most people who cite it do away with the parenthetical at the end—and thus, in my estimation, with the whole point.)[7]

[7] "*J'aime, je n'aime pas*:
I like, I don't like
"*I like*: salad, cinnamon, cheese, pimento, marzipan, the smell of new-cut hay, why doesn't someone with a "nose" make such a perfume, roses, peonies, lavender, champagne, loosely held political convictions, Glenn Gould, too-cold beer, flat pillows, toast, Havana cigars, Handel, slow walks, pears, white peaches, cherries, colors, watches, all kinds of writing pens, desserts, unrefined salt, realistic novels, the piano, coffee, Pollock, Twombly, all romantic music, Sartre, Brecht, Verne, Fourier, Eisenstein, trains, Médoc wine, having change, *Bouvard and Pécuchet*, walking in sandals on the lanes of southwest France, the bend of the Adour seen from Doctor L.'s house, the Marx brothers, the mountains at seven in the morning leaving Salamanca, etc.
"*I don't like*: white Pomeranians, women in slacks, geraniums, strawberries, the harpsichord, Miró, tautologies, animated cartoons, Arthur Rubinstein, villas, the afternoon, Satie, Bartók, Vivaldi, telephoning, children's choruses, Chopin's concertos, Burgundian brandes and Renaissance dances, the organ, Marc-Antoine Charpentier, his trumpets and kettledrums, the politico-sexual, scenes, initiatives, fidelity, spontaneity, evenings with people I don't know, etc.
"*I like, I don't like*: this is of no importance to anyone; this, apparently, has no meaning. And yet all of this means: *my body is not the same as yours*. Hence, in this anarchic foam of tastes and distastes, a kind of listless blur, gradually appears the figure of a bodily enigma, requiring complicity or irritation. Here begins the intimidation of the body, which obliges others to endure me *liberally*, to remain silent and polite confronted by pleasures or rejections that they do not share. (A fly bothers me, I kill it; you kill what bothers you. If I had not killed the fly, it would have been *out of pure liberalism*: I am liberal in order not to be a killer.")
Roland Barthes, *Roland Barthes by Roland Barthes*, trans. Richard Howard, University of California Press, Berkeley 1977, p. 116–117.

II. LIKE AND LIKE

> The pretense of children is not a dream. They are
> playing and they know it. —*Agnes Martin*[8]

[8] Agnes Martin, "What
We Do Not See If We Do
Not See," in *Agnes Martin:
Writings*, Hatje Cantz,
Ostfildern Ruit 1992, p. 118.

Like is a slippery word; it means something like "attracted to," but not quite. It means "attached to," but not always. It means "fond of" or "drawn to" or "fulfilled by," but none of these. The OED has definitions for "like" as a suffix (add it to a word so something can be compared to it, as in "life-like"); as a noun—defined only (and wonderfully)—as "(One's) good pleasure"; as an adverb (in order to approximate one thing to another, as in "You are like a sister to me"); and as two modes of verb usage. The first is "to liken," i.e. to represent. The other is to please (or be pleasing), to pleasure (or be pleasured). All are etymologically related to a now obsolete form, *lich*, which more or less means "body." It probably seems like the above is a whole lot of linguistic gymnastics to get to this point: quite obviously, you are thinking, to like something is to have some bodily relationship to it. But, taken with all its other meanings, this so-very-obvious presence of the body might indeed take on a slightly different slant. If "like" is so often a way to posit sameness ("this is like that") then perhaps the body that "likes" is always seeking, however unconsciously, to take a kind of possession: I *like* that and so I will make it a part of me, or if not me, then at least a part of how I articulate myself, how I hope to be *read* by others. I like artichokes. Artichokes then partially define me. I do not like chocolate. Only its absence stands as a reference point for me—I have no taste for it.

To like, then, is to collect things and ideas and people around oneself. It is to stand behind something, to place value upon it, to willingly (and sometimes unwittingly) align it with oneself and, thus, with some proclamation of importance. To like is to narrate a story of one's self ("One's good pleasure"), as it were. In doing so, to like is also to be physiologically alive, to move into modern life. (To like—to actually like, instead of merely falling into convention—is to effect a gentle rupture.)

Here are one or two things I know about T. J. Wilcox: he likes French bulldogs, high drama (of a Dandyish sort), high couture, bees, cats, birds, minor celebrities who act as though they are major, major celebrities on the way to becoming minor, sentimental keepsakes, prophecies, children's stories (especially tragic ones), children's toys (especially tragic ones), divas of all kinds, Christmas, *fraise des bois*, meandering bus trips, postcards from places he has visited (and places he has not), everything French, reminiscing, sunsets, complaining even when things aren't so bad, cowgirls, watching (but not participating in) *The Rocky Hor-*

ror Picture Show, David Bowie, jewels, annunciation scenes, formal gardens, anything Greek (ancient *or* faux, each for different reasons), using initials in lieu of names, Grand Central Station (but not at rush hour), going to the movies when nobody else is there, glamour, Rococo, etc. (I can't, or rather, won't make a list of Wilcox's dislikes—there is much less palpable evidence to go on, or, better said, the risk is too large that such a list would simply be the result of projection on my part.)

Wilcox's films present so many of his "likes," as ripe berries on the vine. Or, better, as garlands, their tendrils reaching out to intertwine in a kind of ongoing visual web. Garlands isn't my word—it's Wilcox's. In his series of that name, individual films (which now stand at 21, and whose dates of production, beginning in 2003 but conceivably never reaching completion, imply perennial reseeding), are arranged in clusters over six reels, so that a single "garland" might offer up, for instance: an 80-second trip around the world (via postcards); "How to Explain the Ephemeral and Tenuous Character of Life to Children" (by way of Humpty Dumpty—the familiar verse paired with flea-market finds of stuffed, hand-sewn versions of the doomed little egg); a round-trip bus ride from Orient to Mantauk Point (Long Island, that is), that, when mapped, reveals itself as the artist's monogrammatic "W" (better on abstract geography than on any towel); and a chronicle of perfect sunsets (forever the perfect metaphor, but still surprising as a thing-in-itself). Consider this the cliff-note version of *Garland Three*. So far there are six *Garlands*, but Wilcox has hardly stopped counting. Or collecting.

Susan Stewart makes a distinction between the souvenir and the collection that I like in relation to Wilcox's work. The souvenir, she says, is a magical object, but a failed one, since it claims a relationship to a past from which it is, nonetheless, totally divorced. The collection, on the other hand, renders all time synchronous—there is no time but the time that binds together this grouping of objects. The collection, she writes, is "a form of art as play, a form involving the reframing of objects within a world of attention and manipulation of context." (With some embarrassment—but why?—Stewart names the quintessential collection of all time as Noah's Ark. I like thinking of a collection this way. All that T. J. Wilcox would need to sustain himself in a life after the great flood would be honey, beautiful boys, women with throaty voices, various curios, etc. Stewart names this model of the collection a "hermetic world: to have a representative collection is to have both the minimum and the complete number of elements necessary for an autonomous world … ")[9] This means *serious* play, which is to say that the collection is not about frivolity unless one acknowledges that without frivolity we are without pleasure. This also means that things that seem to have no con-

[9] Susan Stewart, *On Longing: Narratives of the Miniature, the Gigantic, the Souvenir, the Collection*, Duke University Press, Durham 1993, p. 151–152.

nection become, suddenly within the collection, made for one another: like and like. (Here is the footnote that marks the second center of this essay.[10])

But the way Wilcox collects, if we can agree that this is what he does, is particular. He does not have the collector's pride in fidelity, which is only to say that he is not held by the idea of things but instead by the interpellation they exert on him in a given moment. (Let's not forget that there is an impersonal use for the verb *to like*, which hails not from the subject but from the object: "it likes me," we may say of something we wish to have. Wilcox's subjects, living or not, appear to like him as much as the other way around.) This lack of fidelity is hardly a lack of seriousness, but it does reveal Wilcox for what he is (insatiable) and for what he does, which I will simply call *cruise*. He cruises—yes, in that sense of the word—*picking things up*, placing them in his orbit. Some more things that circumnavigate there: a roster of the occupants of the Place Vendôme including Pamela Digby Churchill Hayward Harriman and Comtesse de Castiglione *(Garland Five)*; the artist's deceased stepmother, Ann and the brutal death of the Romanovs and their royal dog, Ortino *(Garland One)*, a small army of moribund Kokeshi dolls and the transsexual activist Ara Tripp *(Garland Two)*; the crowning of a rodeo queen and a new model of finger-painting *(Garland Four)*; facts about the origin of the angora cat and theories about the end of the world as conceived by swans *(Garland Six)*.

Roland Barthes likes the word "cruise" (it sounds much better, even, in French: *rouler*, especially since it has obvious affinity with *roulette*), using it himself to describe collecting. A "polyphony of pleasures" is another way he explains the effect of "leaping from one object to another, as chance presents them, without experiencing the slightest sentiment of guilt with regard to the disorder such a procedure involves."[11] Wilcox's leaps effect themselves, in particular, through the thickness of film. Much has been written of his procedures of making: he first films (on Super-8 film) impromptu scenes, staged sets, still photographs, and scenes snatched from other movies. Transferring the footage to video for editing and alteration, it is then given back to celluloid, this time of the 16mm variety. But, what might be described as a "loss" of quality is only a gain in a certain kind of detail: the film's *handling* becomes obvious instead of transparent. So many material transfers serve to illuminate the procedures of desire itself. (Were we to speak analytically, to "like" an object is to experience transference in relation to it.)

Standing or sitting in front of one of his screens (as we would a painting), we are given over to such transferences: Wilcox's to an object, that object to another, that seeming one-off crystallized into its own image. In films prior to the *Garlands*, Wilcox offers

[11] Roland Barthes, "One Always Fails in Speaking of What One Loves," *The Rustle of Language*, trans. Richard Howard, University of California Press, Berkeley 1986, p. 298.

[10] "Like And Like"

A FAIR bell-flower

Sprang tip from the ground:
And early its fragrance

It shed all around;
A bee came thither

And sipp'd from its bell;
That they for each other

Were made, we see well.

— Goethe, 1814

us acquaintance with new versions of his favorite characters. In *The Little Elephant*, Babar (whose traumatic life-change sent him to the city) is suddenly Bowie (not just any Bowie, but rather the Elephant Man and then The Man Who Fell to Earth). *Stephan Tennant Homage* offers a vision of a now little-known 1920s figure, best known for his lavish, self-imposed convalescence. Tennant, *à la* Wilcox, is disinterred and given a new life in the body of his great-niece, the model Stella Tennant. Funerals are ritually carried out with as much pomp and circumstance as possible—the First Emperor of China's, for instance, and Marlene Dietrich's. Where in some cases soundtracks accompany these earlier works (ranging from the Po-mo Chinoiserie of the 1980s band Japan, to dialogue between Wilcox and his subjects), in the *Garlands*, the whirling of Eiki Slim Lines provides the only acoustic signification and this an indexical one: film. Subtitles, which the artist has used from the first, narrate stories that are pared down to their absolute essentials. They read like haiku. Or greeting cards. And always, a flourish: The End (pronounced in fanfare font after each and every gem-like story, whether ten minutes long or barely two). No matter how many times I read it, I feel that sinking-soaring feeling in my stomach. Dénouement in waves, so many little deaths.

It is perhaps telling that the first film Wilcox made was a re-casting of Marie-Antoinette's famous fate. The matriarch's carriage is not—as we are told in history books—overtaken due to its being overloaded with luxurious booty. Instead, in Wilcox's *The Escape (of Marie-Antoinette)*, we have our cake and eat it too. Though the Muybridge-inspired steeds pulling the gilded coach trip awkwardly through an infinitely repeating landscape (the visual equivalent to a skipping record), there is the promise—through deferral if never arrival—of an impossible ending. The effect is one that describes nearly all of Wilcox's work: Marie-Antoinette is spared in order that *we* experience the feeling of being killed: softly.

GILLIAN IN FURS

HILTON ALS

INTRODUCTION

If narrative film means to tell us anything at all, it's the truth. More than documentaries or biopics—"direct" truth's cinematic form—fictional narratives manipulate us into entering the cinema of the self. While documentaries and biopics offer us pre-lived lives made sensational and thus movie-worthy due to the subject's excesses—too much glamour, too much dope, surviving one too many almost grand finales—they don't encourage the level of identification with the protagonist most movie audiences crave. After all, the life re-examined in a biopic or documentary has already been lived. When we watch Cate Blanchett play Katherine Hepburn in Martin Scorcese's 2004 Howard Hughes fantasia, *The Aviator*, say, we expect less of her than if she were to play a character sprung from the mind of a sun-starved screenwriter baking under the heat of a deadline in Los Angeles or Palm Springs. As Katherine Hepburn, Cate Blanchett's performance is somewhat limited by the facts of her real-life character's well-examined life: the auburn hair, the jaunty athleticism, and her love of emotionally damaged, professionally powerful men. But if Blanchett plays a heretofore non-existent character, she can play her given part any way she sees fit. Or almost. She must deal with the director, of course, and the script, and the other real life considerations that make her an artist for hire.

Nevertheless, whatever hair and make-up concerns Blanchett may have vis-à-vis her invented character are not really our concern. Or shouldn't be. When we pursue our dreams in the dark space where movie fiction plays itself out, we want to identify with some aspect of the star's made-up self—to be engaged by and in the drama of her becoming a character.

And yet, increasingly, this is a difficult illusion for the professional performer to maintain, her strange habit of becoming something other than herself. Now, contemporary audiences cleave less to what Artaud called the "magic" or alchemy of the performer living in make believe than we cleave to the star's "persona." This trend—a kind of "reality"

tragedy—is borne of newspapers, and the sad proliferation of TV documentaries, which have become our culture's dominant film eye. By turning our collective back on the magic or allure of the star living emotions "real" people never access in public let alone in private, contemporary audiences are approaching—backwards—narrative film as a medium of unadulterated truth, which it is not. The only truth one should look for in all those frames running through the projector is actors moving in a particular time and place, desperate to impress the camera and thus us with their dream life, which is the performer's greatest gift, their greater truth.

In looking at T. J. Wilcox's work, one is impressed—as in Warhol's early work—with his joyful insistence on delineating the dream world of the star, which gives us something of ourselves. Wilcox's Dietrich is a fake. In one of his films, we have an actress impersonating Dietrich, but only in voice over. But wasn't the "real" Dietrich a fake? A performer perfectly well aware that her job—her calling—was ushering us into dreams past whatever political and economic Depression we happened to be in then? And now: well, we live in a kind of post-Dietrich age, wherein Marlene's famous feathers and lascivious lisp and love of Gabin are as much a part of the story we want to see as Hemingway's beloved "Kraut" swathed in Von Stroheim's gauze.

Wilcox—a true modernist—doesn't reject any of the above. But he doesn't accept the documentary elements of the star's life as the only truth worth reckoning with, either. Nor does he allow the truth to hamper the metaphorical veracity of his characters. His fake Dietrich, his fake Romanov blood, and his real dog, are all true. Or true to the life Wilcox chooses to depict.

As a kind of happy pendant, Wilcox looks at both sides of the story: truth and illusion. So doing, he makes us look at the truth in fiction, the facts to be found in these voices that, if you close your eyes, could be the actresses of tomorrow in a film by T. J. Wilcox, who looks to the future in a star's eyes.

Day: A verandah. Bright sunlight. The deafening sound of birds, a sound that increases or decreases in volume as the scene goes along, sometimes disappearing altogether. On the verandah: a table, nicely laid out. White tablecloth, white China, water glasses filled. Meat on the plates. Seated at the table are two women. Gillian, who wears a coat with a faux fur collar, and Maggie, who wears a wedding dress with the casual aplomb of a T-shirt. Maggie has unbuttoned the back of her dress and shoved the collar down around her shoulders. Gillian has light-colored hair. Maggie has black hair, which she wears pinned up. One of the women is Caucasian. Gillian is slightly younger and knows it.

GILLIAN *(moving the meat around on her plate with something akin to disgust)*: This meat is the wrong color.

MAGGIE *(looking down at her plate)*: What?

GILLIAN: I said the meat is the wrong color.

MAGGIE: How can you tell?

GILLIAN: Look at it! I cook it at home. It doesn't look this way when it comes out of *my* kitchen.

MAGGIE: Oh, really? That's weird. How can you tell it's the same kind of meat you cook at home?

GILLIAN: Because I shop for it. I *buy* it.

MAGGIE: Oh.

GILLIAN: I take my ticket and stand at the meat counter until my number's up. I look through the greasy glass case at the flabs of it.

MAGGIE: Slabs.

GILLIAN: Flabs. Flabs of meat. Pink. Going into your insides *cooked*, unflabbed, so it doesn't look like *this*.
(She moves the meat around on her plate, transfixed.)
Yuck.

Birds screech. Silence.

MAGGIE: If it's so disgusting, then why do you look at it? I mean, why do you feel it? With your fork?

GILLIAN: To remember that it's sickening the next time they ask me to project how sickening it is.
(She prods the meat with her fork again. After a while, she looks up.)
Don't you work that way?

MAGIE: No. I mean, no! Why should I? Do you think I should?

GILLIAN (snorts): Don't tell me you use your *imagination*.

MAGGIE: Why—yes!

GILLIAN: How?

MAGGIE: Well, I just imagine it—the way a thing tastes, something. I don't have to actually eat it the thing to know. And once I've imagined it, I can taste it or see it or hear whatever I'm supposed to because I've already imagined it.

GILLIAN *(sarcastic)*: Like a child playing?

MAGGIE *(slightly put off)*: Well, sort of.

GILLIAN: That's nice.

MAGGIE: There's nothing nice about it. It's just the way I work.

GILLIAN *(cutting her off)*: I knew this actress once. It was ridiculous. She was sitting next to me at a dinner party. Eating meat that was *cooked*.

Birds.

GILLIAN: And I thought: "Well, she's an actress—a star, actually—so, ostensibly, we have something in common. At least, the actress part of ourselves does." Anyway, I wanted to make a little pillow talk—I mean, we were being girls together—and I asked her how she prepared for a role. And she said that she went to playgrounds. And I said, playgrounds? What for? She said, as if this made all the sense in the world: "Why, to observe the children playing there. Their naturalness in pretending." Let me just say I didn't know what she was talking about.

MAGGIE: She meant what I mean. What I just told you. I pretend.

GILLIAN: Yes, well, but what about this *meat*. How can I believe it's not disgusting?

MAGGIE: Am *I* disgusting?

GILLIAN: What?

MAGGIE: Am I disgusting?

GILLIAN *(as if this makes all the sense in the world)*: You're a woman.

MAGGIE: And what else?

GILLIAN (laughing): An actress! So I don't know if you're

disgusting.

MAGGIE: Fair enough. The point is: can't you imagine that when you move the meat around, it's maybe me you're touching?

GILLIAN: And why would I do that?

MAGGIE: To see if you can think of the meat—the flab—as something entirely different. Treat it like a person.

GILLIAN: But it isn't. Nor will it ever be. They put this meat here as though I should *act* with it, as if I *can*. As if the real world doesn't exist.

MAGGIE: Ha. Ha. That's a laugh.

GILLIAN: The meat.

MAGGIE: The world.

Beat. Birds screech. The sun intensifies.

GILLIAN: Anyway, I never did see the point of pretending anything, but here I am, doing it, I guess. A wedding dress. Meat. It's all the same to me.

MAGGIE: Well, if it comes to that, I like your work. I mean, I like what you've done with your lack of imagination.

GILLIAN: Oh, for God's sake. Don't flower it up, as my mother used to say. I haven't *done* anything. Just extra work. I mean, *nothing*.

MAGGIE: But things accumulate. Build. A little star turn here,

a little pirouette there, and people—some people—get a sense of who you are.

GILLIAN *(almost as an afterthought)*: Oh?

MAGGIE: Sure?

GILLIAN: Oh?

Beat.

GILLIAN: And what was your sense of things? I mean, when you saw me on-screen?

MAGGIE: I said to myself: now there's a girl who doesn't mind *not* pretending to get what she wants, or what we want her to have.

GILLIAN: What is that?

MAGGIE: Attention!

GILLIAN: Touché!

They laugh. Perhaps we hear a bit of Joanna Newsom: "Sprout and the Bean." The song fades in and out of the following dialogue, along with birds screeching from time to time.

GILLIAN: I don't know. People just give it to me.

MAGGIE: What?

GILLIAN: Attention. They *want* me to be in their movies, they *like* looking at me. Which generates a certain amount of *contempt*, if you know what I mean.

MAGGIE: I don't. But I can imagine playing it. Give me a hint.

GILLIAN: Ha! A little précis about my feelings?

MAGGIE: Yes. Something like.

GILLIAN: Don't be silly. Nothing is "like" anything else.

MAGGIE: Oh! But don't you want to feel what other people feel?

GILLIAN: Which is what?

MAGGIE: Like everyone else!

GILLIAN: No. So, back to my contempt, if you're interested in playing it. Approximating it or whatever.

MAGGIE *(nearly under her breath)*: Carry on. But I'm getting some idea of how to play it already.

GILLIAN: I was born. People liked looking at me. I always thought the camera was *interesting*, you know? I liked science in relation to my body, my skin. I liked seeing—imagining?—how film—a strip of chemicals—reacted to my skin. Obviously I wasn't being movie filmed as a child. I wasn't an *actress* then—not that I was aware of. But my father took many photographs of me. There were other *children*, I mean, there was a mother, too, but I always seemed to be the one who was being taken—in pictures.

MAGGIE *(as if remembering something else)*: My brother was cute…

GILLIAN: So I got used to it. The camera never bothered me. I took it for what it was: this real thing that reacted to my skin and made something of it. Fiction? Documentary? Both,

I suspect, and somewhere in-between, all at once. What *was* interesting, though—and this is where the contempt comes in—is how people, my father for starters, enjoyed the act of convincing, coaxing me into sitting rather than just telling me to *do it*, you know.

MAGGIE: You preferred direct orders? Having your free will locked up? What do you mean?

GILLIAN: Seduction, plain and simple. Whenever my father got a new roll of film, I knew it was coming. I was a girl. We'd be at the breakfast table and he'd say to my brothers and sisters and mother, but mostly to me, and I knew it: "Harumph. Well. It looks like we might have to take a few pictures down by the lake this afternoon. Whattya say?" Or: "My, my those photographs came back from the drugstore the other day; they give you doubles; it's Christmas time; let's have a look at you and all we possess under the Christmas tree." And we'd do whatever he asked—roll Easter eggs on the front lawn with our tongues—and I could see him seeing me in particular because that's what the picture always came back as and went into plastic albums as: me. What discipline! To pretend to be interested in your wife and other children when, in fact, you're interested in one child in particular to the exclusion of all others. Maybe that's what disturbs me about pretending—the imagination: it's a lie of the mind that focuses on one idea, or one child, and builds and builds and builds on that person to the exclusion of other ideas, other children. And to what end? An untruth? A pretty picture? And who is watching it?

MAGGIE: My brother was cute. People photographed him, and I just tagged along, hoping to get into the frame.

GILLIAN: Well, all that shows in *your* work.

MAGGIE *(curtly; a bit hurt)*: Why, thank you.

GILLIAN: No, I'm serious. Listen: if you're going to be so unkind as to mention my work, why can't I mention yours? Hmmm?

MAGGIE: I guess … Although, like you, I don't feel there's been *much* …

GILLIAN *(imitating Spencer Tracey)*: But what there has been has been *cherce*.

They laugh. Birds screech. Perhaps another song is heard by now.

GILLIAN: Pathos is the word that comes to mind when I see you up there on the big screen, a kind of sad wandering, something lost, but who can say what, which has it's charms.

MAGGIE *(simulating erotic pleasure)*: Oooo! I didn't know you cared.

GILLIAN: I don't. Or at least that's *my* affect. Not caring. *(She chuckles.)* But somewhere underneath not caring—the old not wanting to be photographed ploy—I do care. But cheese it, I wouldn't want that to get around.

MAGGIE: Maybe that's why they put us together. We project different emotional information, somehow.

GILLIAN: Something like. But who knows? It's the movies. Such a funny business, isn't it? To be involved in something where you're constantly waiting for approval to be conferred by people who—how to put it?—are less than one's intellectual equal?

MAGGIE: I never thought about it that way, and, if I did, I suppose I wouldn't be sitting here in costume talking to you,

thinking about meat. I'd be somewhere …

GILLIAN (sarcastic): Running a farm? What? With a *lover*?

Terrible music.

MAGGIE (musing): In a field of green. My arms outstretched. No telephone, no. Dew. A lamb licking my face clean.

GILLIAN (laughing): Oh, my dear, don't you realize that's another movie? It's too late for us to assume what the real world would call having a normal life. As *women*. We make things up. We're babies in dew. We pretend our breasts are leaking when it comes time for the feeding because we can't be touched for real. Reality, so called, isn't interesting. Husbands. Neighbors. Boredom. No one told us how to play any of that in life, so we make it up because it would be too awful not to, otherwise. If not, what would we have?

MAGGIE: A few dates, I guess.

Sound: crackling, as though turning dials on a radio.

MAGGIE: Do you like hanging out with actors?

GILLIAN: As a rule?

MAGGIE: Well, as—I don't know. Is there a rule to actors? I'm trying to describe some kind of community feel. Tea with the like-minded. That sort of thing.

GILLIAN: Oh, my God, no. I'm the absent type, dearie. Once I'm out of costume, I leave the scene of the crime, otherwise known as the set.

MAGGIE: The absent type?

GILLIAN: Yes.

MAGGIE: Well, obviously I'm not. And maybe you're not, either. Since you're sitting here, talking to me.

GILLIAN: It's called acting.

MAGGIE (disappointed): Oh.

GILLIAN (not taking it back): No, no, what I mean by other people is this: I don't feel like one. I see them as character studies; I don't know the way they *really* are.

Birds. A light chirping.

MAGGIE: You mean, eating meat? Why they don't like it, and so forth?

GILLIAN: No, no. How they *really* are. The horror of DNA. What they can't escape: themselves.

MAGGIE: Which no one can. But as an actress-lady friend of mine once said about our profession: we're metaphors about real people.

Birds.

GILLIAN: Yes.

Birds.

Born in 1965, Seattle (WA).
Lives and works in New York.

EDUCATION

1985-1989 School of Visual Arts, New York, BFA
1993-1995 Art Center College of Design, Pasadena CA, MFA

SOLO EXHIBITIONS

2006
Garlands, Galerie Meyer Kainer, Vienna
Galerie Daniel Buchholz, Cologne, Germany

2005
Archiv & Erzählung: John Stezaker und T. J. Wilcox, Kunstverein Munich, Munich, Germany
Galleria Raffaella Cortese, Milan, Italy
Museum of Modern Art, New York (screening)
T. J. Wilcox: Garlands, Metro Pictures, New York
Museum Ludwig, Cologne, Germany (screening)

2004
A Garland for Ireland, Temple Bar, Dublin

2003
Garlands, Sadie Coles HQ, London; China Art Objects, Los Angeles
Tate Modern, London (screening)

2002
Oh my GR-DVM5, oh oh, GR-DVM5, Metro Pictures, New York
MATRIX 198 Smorgasbord, UC Berkeley Art Museum and Pacific Film Archive, University of California, Berkeley (CA)*
T. J. Wilcox: The Little Elephant, Transmission Basement, Glasgow (screening)

2001
Galerie Meyer Kainer, Vienna
Sadie Coles HQ, London
Galerie Daniel Buchholz, Cologne, Germany
The Lux, London (screening)

2000
Gavin Brown's Enterprise, New York
Kunsthaus Glarus, Glarus, Switzerland

1999
T. J. Wilcox: Das Begräbnis der Marlene Dietrich / The Funeral of Marlene Dietrich, Galerie Neu, Berlin
Gavin Brown's Enterprise, New York
Sadie Coles HQ, London
Galerie Daniel Buchholz, Cologne, Germany

1998
ICA, London*

1997
Galerie Daniel Buchholz, Cologne, Germany
The Death and Burial of the First Emperor of China, Gavin Brown's Enterprise, New York

1996
Gavin Brown's Enterprise, New York

GROUP EXHIBITIONS (Selection)

2006
The World's Most Photographed, Museum Ludwig, Cologne, Germany
Gifts of Sound and Vision, 20 St. Andrews Street, Glasgow, Scotland

2005
Superstars: From Warhol to Madonna, Kunsthalle Wien and Kunstforum Wien, Vienna*
May You Live in Interesting Times, Cardiff Festival of Creative Technology, Wales
Gifts of Sound and Vision, Glasgow International Festival of Contemporary Visual Art, Glasgow
Deriva Mental, Museo Tamayo Arte Contemporáneo, Bosque de Chapultepec, Mexico (screening)
Restaurant Georges Costes, Centre Pompidou, Paris (screening)

2004
North Fork/South Fork, Parrish Art Museum, Southampton (NY)*
Genealogies of Glamour: The Future Has A Silver Lining, Migros Museum für Gegenwartskunst, Zurich*
Whitney Biennial, Whitney Museum of American Art, New York*
Concert In The Egg, The Ship, London

2003
Drawings, Metro Pictures, New York
Today's Man, John Connelly presents, New York; Hiromi Yoshii, Tokyo
My People Were Fair and Had Cum in Their Hair (but now they're content to spray stars from your boughs), Team, New York
Fast Forward: Media Art Sammlung Goetz, ZKM, Karlsruhe, Germany
Somewhere Better Than This Place, Contemporary Arts Center, Cincinnati*

2002
Confiture demain…, Centre Régional d'Art Contemporain, Sète, France*
Metro Pictures, New York
Rapture: Art's Seduction by Fashion since 1970, Barbican Centre, London*
The Americans: New Art, Barbican Centre, London*
Metro Pictures, New York
W, Musée des Beaux-Arts de Dole, France*

2000
Greater New York, PS1, New York
The American Century – Art & Culture 1900–2000, Whitney Museum of American Art, New York

1999
Moving Images, Galerie für Zeitgenössische Kunst, Leipzig, Germany
Center for Curatorial Studies, Bard College, Annandale-on Hudson (NY)

1998
El Nino, Museum Abteiberg, Mönchengladbach, Germany
Dialogues (with Sam Easterson), Walker Art Center, Minneapolis (MI)*

1997
XLVII Venice Biennale, Venice, Italy
Sunshine and Noir, Art in Los Angeles, 1960-1997, Louisiana Museum of Art, Denmark; touring to Kunstmuseum Wolfsburg,
 Wolfsburg, Germany; Castello di Rivoli, Turin, Italy; UCLA at The Armand Hammer Museum of Art, Los Angeles (CA)*
Whitney Biennial, Whitney Museum of American Art, New York*

1996
Studio 246, Marc Foxx Gallery, Los Angeles (CA)
Hollywood, LACE, Los Angeles (CA)
Los Angeles Center for Photographic Studies, Los Angeles (CA)
Persona, Kunsthalle, Basel, Switzerland and The Renaissance Society, University of Chicago (IL)*
Affairs, The Institute for Contemporary Art, Vienna
Studio 246, Kunstlerhaus Bethanien, Berlin
Sampler II, David Zwirner Gallery, New York
Contemporary Collections, L.A.C.P.S., Los Angeles (CA)

1995
Art Center College of Design, Pasadena (CA)
The Big Night, Bradbury Building, Los Angeles (CA)
Fabrication, The Guggenheim Gallery, Chapman University, Orange (CA)

2003–2005
Garlands 1–6

2002
fraise des bois
Ladies Room (Twenty Questions)

2001
Midnite Movie

2000
Hadrian and Antinous
The Little Elephant

1999
The Funeral of Marlene Dietrich

1997
The Death and Burial of the First Emperor of China
Stephen Tennant Homage

1996
The Escape (of Marie-Antoinette)

BOOKS AND CATALOGUES (Selection)

2005
Elizabeth Hamilton (ed.), *The Blake Byrne Collection* (Los Angeles: MOCA)

2004
Tom Holert & Heike Munder (eds.), *The Future Has a Silver Lining. Genealogies of Glamour*
(Zurich: Migros Museum für Gegenwartskunst & JRP|Ringier)

2003
Stephan Urbaschek, *Fast Forward: Media Art Sammlung Goetz* (Munich: Kunstverlag
Ingvild Goetz & Sammlung Goetz)
Somewhere Better Than This Place (Cincinnati: Contemporary Arts Center)

2002
Maurizio Cattelan, Massimiliano Gioni, & Ali Subotnick (eds.), *Charley 02* (Dijon:
 Les Presses du réel)
Chris Townsend, *Rapture: Art's Seduction by Fashion since the 1970s* (London:
 Thames and Hudson)
Heidi Zuckerman Jacobson & Phyllis Wattis, *Smorgasbord* (Berkeley: Berkeley Art
 Museum, University of California)
Uta Grosenick & Burkhard Riemschneider (eds.), *Art Now* (Cologne: Taschen)

2001
Mark Sladen (ed.), *The Americans* (London: Barbican Centre)
Bob Nickas (ed.), *W* (Dole: Musée des Beaux Arts de Dole)

1998
T. J. Wilcox (London: ICA)
Dialogues: Sam Easterson, TJ Wilcox (Minneapolis: Walker Art Center)

1996
Persona (Basel: Kunsthalle Basel)

ARTICLES (Selection)

2005
James Quandt, "FILM BEST OF 2005," *Artforum*, New York, December
Kirsty Bell, "T. J. Wilcox," *Afterall*, London & Los Angeles, October
Bettina Funcke, "T. J. Wilcox: From Dusk till Dawn," *Afterall*, London & Los Angeles,
 October
Michaël Amy, "T. J. Wilcox at Metro Pictures," *Art in America*, New York, October
Charles LaBelle, "T. J. Wilcox," *Frieze*, London, April
Johanna Burton, "T. J. Wilcox," *Artforum*, New York, April
Scott Rothkopf, "T. J. Wilcox Curates," *Artforum*, New York, April
Merrily Kerr, "T. J. Wilcox – Metro Pictures," *Flash Art International*, Milan, March/April
Roberta Smith, "Art in Review, TJ Wilcox: 'Garlands'," *New York Times*, 11 February
Sophie Fels, "Garlands," *Time Out*, New York, 10–16 February
Katy Siegel, "All Together Now: Crowd Scenes in Contemporary Art," *Artforum*,
 New York, January

2004
"The Artists' Artists," *Artforum*, New York, December
Reena Jana, "The Recovery of Memory," *Tema Celeste*, Milan, September/October
Dan Cameron, Dan Fox, Jennifer Higgie, Matthew Higgs, Katy Siegel, Roberta Smith
 and Neville Wakefield, "American Pie," *Frieze*, London, June
Helen A. Harrison, "Unforeseen Irises Meteor Asking Big Questions–North Fork/
 South Fork," *The New York Times*, 30 May
Scott Rothkopf, "Subject Matters," *Artforum*, New York, May
"Whitney Bound," *V*, New York, Spring
Renato Diez, "Alla Biennale de Whitney, torna la Pittura," *Arte*, Milan, April
Malik Gaines, "T. J. Wilcox," *artUS*, Los Angeles, January/February
Katy Siegel, "All Together Now, Crowd Scenes in Contemporary Art," *Artforum*,
 New York, January

2003
Eliza Williams, "T. J. Wilcox," *Tema Celeste*, Milan, September/October
Martin Herbert, "T. J. Wilcox," *Time Out*, London, 18-25 June

2002
Katy Siegel, "Best of 2002 – TJ Wilcox," *Artforum*, New York, December
Massimiliano Gioni, "Drama Queen," *Flash Art*, Milan, May/June
Terry R. Myers, "The Americans: New Art," *Artext*, Los Angeles, Spring
Holland Cotter, "Cinema à la Warhol, With Cowboys, Stillness and Glamour,"
 The New York Times, 5 April

2001
Sarah Kent, "Altered States," *Time Out*, London, 28 December
Richard Cork, *Play*, 27 November
Nick Hackworth, "Puddles, Plants and one small joy," *Evening Standard*,
 London, 6 November
Chris Mugan, "Along came a spider," *Evening Standard*, London, 24 October
Jonathan Jones, "The Age of Anxiety," *The Guardian*, London, 23 October
Dan Fox, "Straight to Video," *Frieze*, London, October
Amanda Sharp, "The Americans," *Arena Homme +*, London, Autumn
TJ Wilcox, "Cultural Tourism – The Carlyle Hotel," *Frieze*, London, September
Daniel Birnbaum, "The Americans: New Art," *Artforum*, New York, September
Charles Ruas, "T. J. Wilcox at Gavin Brown's Enterprise," *Art in America*, New York, June
Michael Archer, "T. J. Wilcox," *Artforum*, New York, April
Paul Clark, "Review," *Evening Standard*, London, 2 March
Mark Currah, "Review," *Time Out*, London, 14–21 February
Sarah Gavlak, "A Queer Sensibililty," *Pride*
Jessica Lack, "T. J. Wilcox," *The Guardian*, London, 27 January
Paul Clark, "Art: TJ Wilcox," *Evening Standard*, London, 24 January

2000
Holland Cotter, "T. J. Wilcox," *The New York Times*, 10 November

1999
Martin Herbert, "Review," *Flash Art*, Milan, October
Lawrence A. Rickels, "The Loss Generation," *Art/Text*, Los Angeles, No. 64
Sarah Kent, "Review," *Time Out*, London, 15 June
Robin Dutt, "T. J. Wilcox: The Funeral of Marlene Dietrich," *What's On*, London,
 16 June
Dale McFarland, "T. J. Wilcox – ICA, London," *Frieze*, London, January/February

1998
Sarah Kent, "Review," *Time Out*, London, 21–28 October
Amra Brooks, "A Conversation with T. J. Wilcox," *Zingmagazine*, New York, Summer
Bill Arning, "Review," *Art in America*, New York, April

1997
X-TRA, Los Angeles, volume 1 / No. 3, Fall
Robin Updike, "Area artist's images score a N.Y. coup," *Seattle Times*, 25 May

Edited by
T. J. Wilcox

Designed by
Joseph Logan

Editorial Coordination
Lionel Bovier, Sadie Coles, Helene Winer

Editing and Proofreading
Clare Manchester, Sara Harrison (Sadie Coles HQ), Tom Heman (Metro Pictures)

Color Separation & Print
Musumeci S.p.A., Quart (Aosta)

Acknowledgements
All images courtesy of Galerie Daniel Buchholz, Cologne; Sadie Coles HQ, London; Metro Pictures, New York

The artist would like to thank Helene Winer, Janelle Riering, Tom Heman, Manuela Mozo, Beth McDonough,
Laetitia Lavie, and all at Metro Pictures; Sadie Coles, Pauline Daly, and all at Sadie Coles HQ; Daniel Buchholz,
Christopher Müller, and all at Galerie Daniel Buchholz; Johanna Burton and Hilton Als, Joseph Logan,
Phil Kovacevich, and Todd Huckleberry for their kind help and generous support in the realization of this project.

Published by
JRP|Ringier
Letzigraben 134
CH-8047 Zurich
T +41 (0) 43 311 27 50
F +41 (0) 43 311 27 51
E info@jrp-ringier.com
www.jrp-ringier.com

In collaboration with
Galerie Daniel Buchholz, Cologne
Sadie Coles HQ, London
Metro Pictures, New York

ISBN 10: 3-905701-96-0
ISBN 13: 978-3-905701-96-8

JRP|Ringier books are available internationally at selected bookstores and the following distribution partners:

Switzerland
Buch 2000, AVA Verlagsauslieferung AG, Centralweg 16, CH-8910 Affoltern a.A., buch2000@ava.ch, www.ava.ch

France
Les Presses du réel, 16 rue Quentin, F-21000 Dijon, info@lespressesdureel.com, www.lespressesdureel.com

Germany and Austria
Vice Versa Vertrieb, Immanuelkirchstrasse 12, D-10405 Berlin, info@vice-versa-vertrieb.de, www.vice-versa-vertrieb.de

UK
Art Data, 12 Bell Industrial Estate, 50 Cunnington Street, London W4 5 HB, info@artdata.co.uk, www. artdata.co.uk

USA
D.A.P./Distributed Art Publishers, 155 Sixth Avenue, 2nd Floor, New York, NY 10013, dap@dapinc.com, www.artbook.com

Other countries
IDEA Books, Nieuwe Herengracht 11, 1011 RK Amsterdam, idea@ideabooks.nl, www. ideabooks.nl